LIGHT FOR VISUAL ARTISTS

Published by
Laurence King Publishing Ltd
361–373 City Road
London EC1V 1LR

email: enquiries@laurenceking.com

www.laurenceking.com

First published in 2010.
This edition published in 2020.

A catalogue record for this book is
available from the British Library

ISBN: 978 1 78627 451 9

Commissioning Editor: Kara Hattersley-Smith

Senior Editor: Sarah Silver

Copy Editor: Kirsty Seymour-Ure

Picture research: Peter Kent

Original design concept by
Brad Yendle, Design Typography

Cover design: Alexandre Coco

Cover artwork: Richard Yot

Printed in China

Laurence King Publishing is committed to ethical
and sustainable production. We are proud
participants in The Book Chain Project®
bookchainproject.com

LIGHT FOR VISUAL ARTISTS

Understanding and Using Light in Art & Design

Second Edition

Richard Yot

LAURENCE KING PUBLISHING

FOREWORD

Welcome to this revised and updated edition of
Light for Visual Artists. My original motivation for
writing this book many years ago was the lack of any
equivalent in the market – light as a subject for artists
had been neglected.

So I wrote the original book to fill the gap and to present
the information in a concise and accurate way, mixing
both scientific and artistic concepts together in an
accessible manner. It was always my intention for the
book to be aimed at a very wide audience, not just
painters and illustrators but also digital 3-D artists,
photographers, cinematographers and compositors –
anyone whose work depends in one way or another
on light to help tell a story.

What makes this book unique is that it can be applied
to any field of visual art; it also deals with all aspects of
light, from science to storytelling and symbolism. The
book is intended to delve into both the how and the why,
the craft and the art.

The second edition has seen some substantial changes,
with many new images and some updates in the text to
reflect the additional knowledge and experience I have
acquired since writing the original book ten years ago.

I hope that by providing a solid real-world foundation
for the mechanics of light I can help artists to take
creative decisions more freely. Knowing the rules allows
for better judgement when it comes to either applying
them, or breaking them.

Richard Yot

PART 1

LIGHTING FUNDAMENTALS

This introductory section explains the essential aspects of light and how to depict them in any situation. Different types of lighting, and what makes each unique, are described in detail. How light interacts with matter is explained, along with detailed and physically accurate explanations of how and why different materials react to light in their own unique ways.

1: BASIC PRINCIPLES

This introductory chapter examines the fundamentals of everyday lighting situations, providing you with all the information you need to develop an understanding of how light works in normal daylight and in artificial light. Light is not difficult to understand, but it does require a conscious effort to observe its effects because you don't usually notice them in everyday life. Once your eyes have been opened, however, you will discover a whole new dimension to the world that will greatly enhance your visual perception and your aesthetic sensibilities.

On a cloudless day, blue light scattered by the earth's atmosphere shines on everything around us. Note the blue tones on the building and windows.

How light behaves

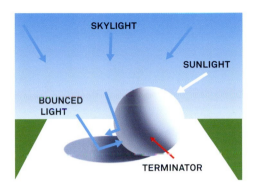

This first section of the book uses a diagram of a white ball on a white ground to demonstrate how light behaves in different everyday situations. Here it illustrates a sunny afternoon. The main source of light is the sun, while the blue sky supplies a second source of light with very different characteristics. Some bounced light between the white base and the ball supplies a third source of light.

The brightest light is coming from the sun and is white light emanating from a small source, which causes it to cast sharp-edged shadows. The second source, the blue sky, is a very large light source and, as a result, creates very soft shadows (which are completely masked by the direct light coming from the sun). The smaller the source of the light, the harder the shadows.

The light coming from the blue sky has a very strong colour cast, which affects everything in this scene. The shadow cast by the ball is blue because it is illuminated by blue skylight, since the ball is shielding it from the white light of the sun. Those parts of the ball not in direct sunlight also take on a blue hue because they are lit by the blue sky.

Finally, the light that is reflected between the card and the ball is also predominantly blue (even though the card and ball are white), since it is blue skylight that is being reflected by the white objects. The surfaces that are closer together receive more of this reflected light than those that are further apart; the bottom part of the ball is lighter than the centre because it is closer to the white card.

The darkest areas in the image are the base of the cast shadow and the border between the areas of the ball that are in sunlight and in shade: this zone is called the terminator. The base of the cast shadow is very dark because it receives no sunlight and the ball is masking it from most of the skylight and bounced light. The other end of the cast shadow is lighter because it is receiving more light from the sky as well as bounced light from the ball.

WHY IS THE TERMINATOR THE DARKEST AREA ON THE BALL?

This is partly because of the effect of contrast – being so near to the very bright side of the ball in sunlight makes it appear to be darker – but it is also receiving less of the bounced light reflected by the white card. So, unlike the rest of the ball, which is receiving either full sunlight or light reflected from the white card, its main source of illumination is the blue sky. It is the area in between the main light (the sun) and the fill light (the reflected light from the card).

WHY IS THE LIGHT FROM THE SKY BLUE?

Visible light is made up of particles of pure energy called photons, which have different wavelengths depending on their colour: blue light comprises photons with shorter wavelengths, whereas red light is made up of photons with longer wavelengths.

White light from the sun is composed of a continuous spectrum of colours, conventionally divided into the colours of the rainbow (with progressively longer wavelengths: violet, indigo, blue, green, yellow, orange and red). It is the mixture of these colours that produces white.

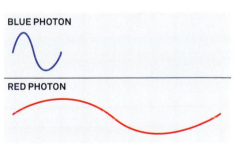

This diagram represents the differing wavelengths of the photons that make up red and blue light.

However, when light travels through the atmosphere of the earth, the shorter wavelengths of light become scattered. The earth's atmosphere is composed of various gases, and these gases scatter light when the electrons within them interact with light. Photons travelling through the atmosphere encounter the electrons, which can absorb and re-emit them and point them in a different direction, causing a diffuse scattering effect. Shorter wavelengths are more likely than longer ones to be diffused, so the photons scattered in all directions by this interaction are predominantly blue.

Longer wavelengths of light, such as red, can travel further through the atmosphere without being scattered. This is why sunsets are red: as the sunlight travels through a thicker layer of air to reach us when it is lower in the sky, a lot of the blue light is lost from scattering, and the light that remains is predominantly red.

The effect of blue photons bouncing in all directions is an atmosphere that actually glows with blue light, an effect that is clearly visible from space. This blue light is strong enough to illuminate areas that are not in direct sunlight, which is why you can still see when you are in open shade.

The shadows in this photo have a strong blue cast because they are being illuminated by the blue sky.

The sun's light glows red at sunset because the shorter blue wavelengths have been lost thanks to scattering. Note, however, that the scattered blue light is reflecting back from the eastern sky and acting as a fill on the foreground waves.

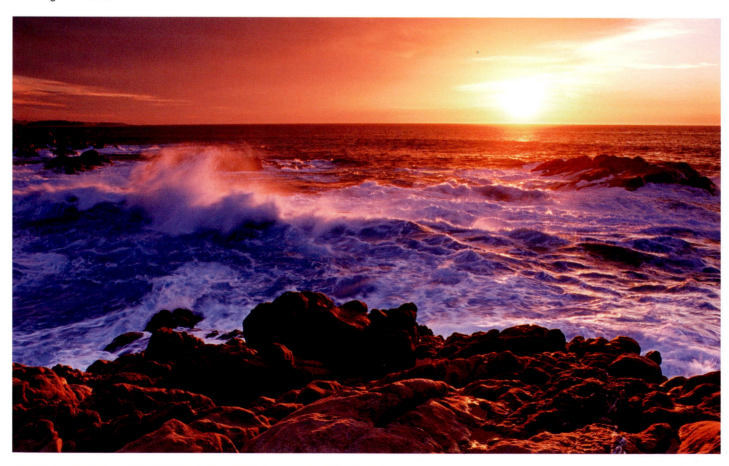

Radiance

When light hits a surface it either bounces or is absorbed by it, depending on the colour of the surface. A white object will reflect all wavelengths equally, whereas a black object will absorb them all. When white light hits a red surface the blue and green wavelengths are absorbed and the red light is reflected.

So, if white light hits a red surface the photons reflected by the surface will be red. When these photons hit the next surface in their path they will therefore illuminate it with red light. This phenomenon is known as radiance, and causes the colours of adjacent objects to have an effect on each other.

Radiance is usually a subtle effect, and it takes a great deal of light for it to become apparent. In soft or dim light it may not be visible at all, but in bright light it can add a lot of colour to the surfaces it affects. Light reflecting between objects of the same colour can create a very saturated effect – the bounced light reinforces the existing colour of the underlying surface, making it glow vividly. Take a look at the real-world examples shown here to see the effect. You will sometimes see this phenomenon in bright daylight.

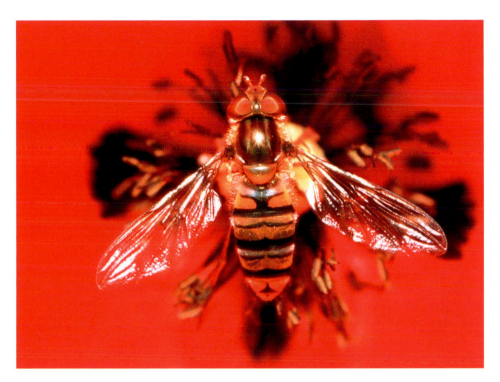

ABOVE The abdomen of this insect has been strongly coloured by red light reflecting from the poppy.

RIGHT The sunlight bouncing off the red sofa is creating a noticeable red tint on the white walls and ceiling.

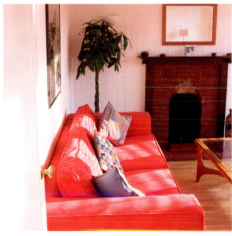

RIGHT The light reflecting from this venetian blind is projecting the colour of the wood onto the wall.

FAR RIGHT As the light bounces between these wooden slats the colour of the wood is enhanced because light of the same colour is reflecting back onto it. The coloured light and the underlying surface combine to create a glowing and saturated version of the wood's existing colour.

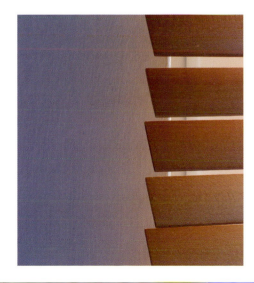
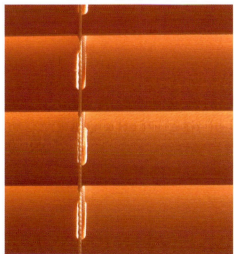

Balancing light and shade

How you will choose to represent a scene is subjective and open to interpretation. Most situations will have a light to shade ratio that produces a balanced range of light and dark, which is what we perceive to be normal. However, there are some situations where the natural order of things tends towards either extreme of light or dark, such as fog or snow on the one hand, or night-time on the other. Alternatively, you might choose to emphasize one of these extremes for visual impact, or to convey a specific feeling.

HIGH-KEY LIGHTING

High-key images have a predominance of white or very light tones and tend to look light and airy. High-key lighting is often (but not always) soft, and detail is generally low. In nature, high-key lighting is found in fog and snow, where even shadows are light, thanks to the amount of reflected light bouncing around.

LOW-KEY LIGHTING

Low-key images have very little light in them. Contrast is usually high and the lighting is hard. Low-key lighting can create a very moody atmosphere and is often used for this effect. The most obvious setting for low-key lighting is night-time, but it can also be found in other situations, such as during storms and in dark interiors.

The stark simplicity of this photograph is created by its limited palette: white and some dark greys and blacks.

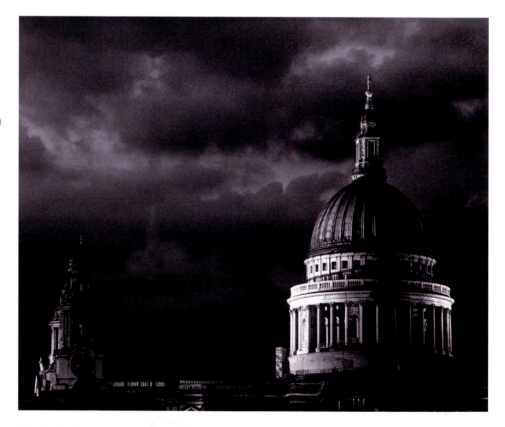

The drama of this image is emphasized by the low-key lighting.

White balance

Most light sources in everyday situations have a colour cast, although the brain is very good at filtering this out. As long as there is a vague mixture of the three primaries in the light, the brain interprets it as white. Even under lighting with very strong colour we have the ability to filter the information our eyes receive and make sense of the colours so that we perceive them in a relative manner rather than an absolute one.

The obvious way of demonstrating this is to use a digital camera with the white balance set to daylight: this is a neutral setting, which will reflect the colours that are actually there.

The brain will convert the colours to make them resemble the first image, top left, but the camera paints the true picture, top right. An easy way to confirm this fact is to look at windows from the outside: next time you are outdoors in the evening look at the colour coming from the windows of houses and you will see that the house interiors are bright orange. When we aren't directly under the light source we can see its true colour.

Something very similar happens when we stand in open shade, where the light is very blue. We perceive the light as being neutral, but if we step back and look at the shade from under sunlight, the blue cast is much easier to see. There are many other situations where lights have a strong cast: fluorescent light is often green, street lighting is very deep orange, evening sunlight progresses from a light yellow to a deep red, and so on.

The image has been shot with a window acting as the light source. The light is coming indirectly from an overcast sky and is relatively neutral.

The blinds have been closed and standard household light bulbs are the light source. The strength of the colour cast in this image may well have surprised you, since tungsten lighting is not usually perceived as being such a bright yellow/orange.

From within open shade we perceive the light as being neutral, but stepping back reveals it to be a deep shade of blue.

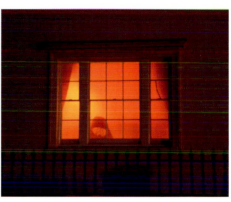

Viewing tungsten light from outside helps to reveal its true colour. Here it looks bright orange, whereas inside the room this would not be nearly so noticeable.

Three-point lighting

A commonly taught lighting technique is the classic three-point lighting set-up, and beginners are sometimes encouraged to use this as an effective way of lighting their scenes. Three-point lighting was originally developed as a way of lighting for film, and its one benefit is that it is easy to learn and understand. It consists of a bright main light coming from one side, dim fill light coming from the opposite side, and a back light behind the subject, which is used to pick out edges and highlight form.

The biggest problem with this set-up is that it is artificial and doesn't reflect reality. The use of back lighting particularly should be considered only if you are looking for a specific effect, since it is so dramatic and recognizable. Back lighting can be very effective but it should be used with flair rather than applied blindly to every situation.

The technique originally arose from early film and photography, before the availability of larger, softer lights, when lights were hard with sharp shadows. The early days of computer graphics were faced with the same problem because large, soft lights were too slow to render, so artists turned to this old technique from the 1940s to help soften their lighting.

Of course as soon as filmmakers and photographers were able to use larger, softer lights the technique of three-point lighting was abandoned, and it would look a little outdated in a contemporary product shot or film. Digital artists on the whole have done the same, because there are other, more naturalistic and aesthetically pleasing approaches available to them now.

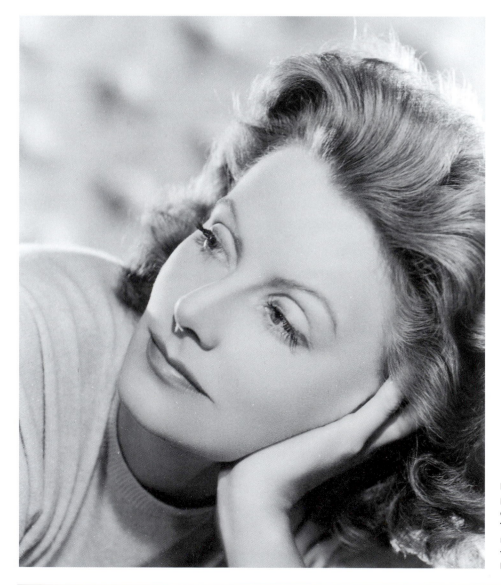

Initially favoured by filmmakers and photographers, three-point lighting can often give a clichéd appearance. This shot of Greta Garbo is instantly recognizable as having the traditional Hollywood three-point lighting set-up.

EXERCISE 1
Observation

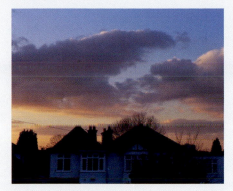

When you see everyday occurrences such as this sunset, photograph and study them. Train yourself to appreciate the everyday.

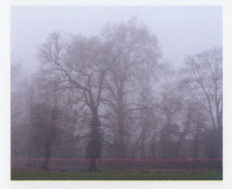

Rarer occurrences are even more worthy of your attention; learn what makes them special and how they differ from the norm.

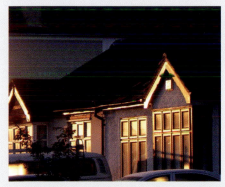

A great example of photographing the light – the reflected sunset on the timber and the windows is very eye-catching. The subject is mundane but the light is not.

Most people go through life taking light for granted, never really noticing how it looks, where it's coming from or what qualities it might possess. It takes a leap of the mind to start really noticing the actual qualities of the light around you. To get the most from this book you are going to need to make this leap. Start looking and start noticing.

Observe the light. What colour is it? What is its main source? Are there any other light sources? Is it direct light from a bulb or the sun, or is it diffuse light from the sky or a window? Are there any shadows? Do they have a hard edge? Are there any atmospheric factors affecting the light, such as mist, dust or haze? Is the light pleasing to the eye? If yes, why?

The very best thing you can do to train your eye and your appreciation of light is to get a camera and photograph the light. Make light itself your subject, both outdoors and indoors: photograph dusk, midday, early morning and late evening; photograph indoors by a window, by the television, under a light bulb. Try to make each situation interesting and get the best out of each kind of lighting.

By building up a collection of images and observations you will gain a greater appreciation of the variety of light around you and the qualities of different kinds of light. Many people think that overcast days are ugly and dull, but the diffuse light of cloudy days can be beautiful if you learn to look for what it can reveal about texture, form and colour.

Never make any assumptions – it's only by looking and noticing that you will learn what works for you and what doesn't, and that's what this exercise is all about.

2: LIGHT DIRECTION

The direction from which we view a light source has a profound effect on our perception of it, and on how the objects in a scene will appear. Choosing the direction from which your main light is coming is one of your most important decisions when lighting a scene, since it will have such a big impact on its appearance and the emotions conveyed by your image.

The quality and direction of light gives these otherwise identical images entirely different moods.

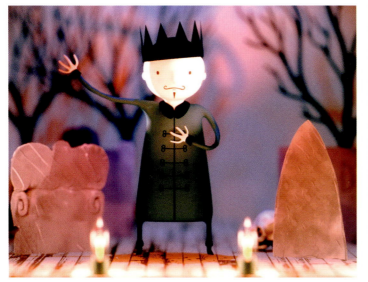

Front lighting

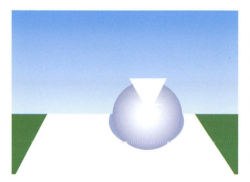

Diffuse lighting from the front smooths over form and can result in loss of detail.

Front lighting can make a scene look rather flat, as it isn't especially good at revealing form and texture.

Front lighting is where the light source is directly behind the observer's point of view. In some situations very attractive images can result from soft frontal lighting, such as the softened form of the leaf, above right.

Front lighting does little to reveal form or texture since any shadows are mostly hidden from view, and as a result it can make things look flat. However, soft, diffuse frontal lighting can be flattering to some subjects for this very reason – it can help conceal wrinkles and blemishes, so it is quite often used in portrait and product photography. Soft front lighting is generally attractive and is the kind of lighting encountered at the beginning and end of the day when the sun is behind us.

A drawback of using front lighting is that areas of an image can look washed out. In portrait photography, for instance, hard front lighting has generally been used on men rather than women because the contrast can be rather harsh.

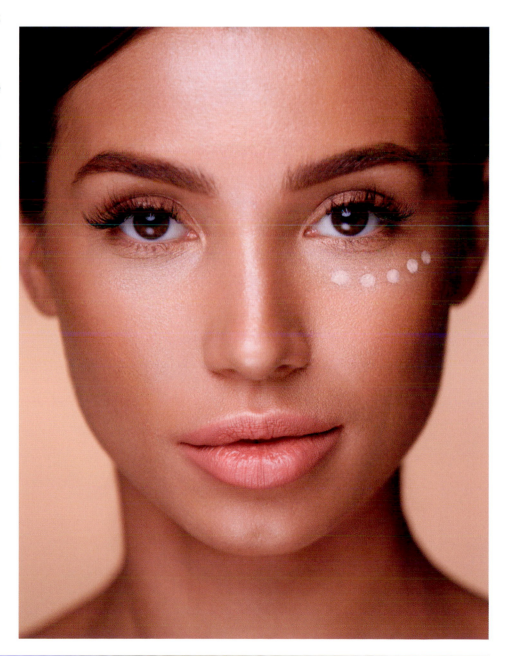

Soft front lighting irons out any imperfections and gives the model's skin a soft, uniform appearance.

Side lighting

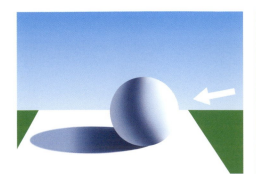

Side lighting is very good for showing form and texture and lends a three-dimensional quality to objects. Shadows are prominent and, as a result, contrast can be high. You can use side lighting to throw dramatic shadows onto surfaces such as walls to create atmosphere. Side lighting is generally attractive and is often used to great effect: it is the type of lighting encountered at the beginning and the end of the day and, as such, is often seen in films and photographs.

Some potential drawbacks of using side lighting are that areas of an image can be lost in shadow and imperfections and wrinkles can be revealed. In portrait photography it has traditionally been used on men rather than women because, as with hard front lighting, it can look harsh, especially if the shadows aren't soft-edged.

The texture of this wall is revealed by the light of the evening sun raking across it.

Side lighting has been used to reveal the form and texture of this leaf.

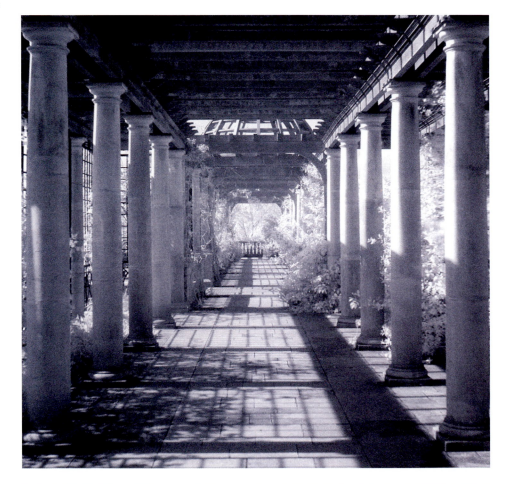

Long shadows cast across this image of a colonnade create a sense of depth and dimension.

Back lighting

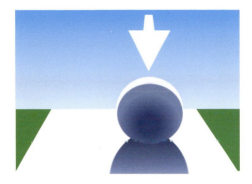

Back lighting is where the viewer is looking into the light source, and objects will have their lit sides facing away from us, so that they are either silhouetted or darkly lit by the fill light. It is usually a high-contrast situation and can often look very atmospheric and dramatic. If the light source is at a slight angle relative to your point of view, objects will have a rim of light defining one or more of their edges. The harder the light the more pronounced this rim will be.

Back-lit scenes usually contain a lot of shadow unless the light source is very soft. Most of the time the image will be predominantly dark with dramatic pools of light. The rim lighting that occurs in this situation can be very useful for defining forms among the shadows. Another feature of this kind of light is that it reveals transparency, translucency and any fine detail or texture along rim-lit edges. Back lighting is thus very effective for lending drama to an image.

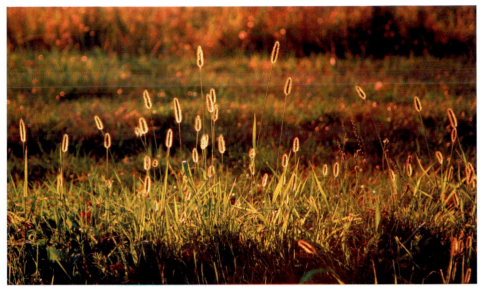

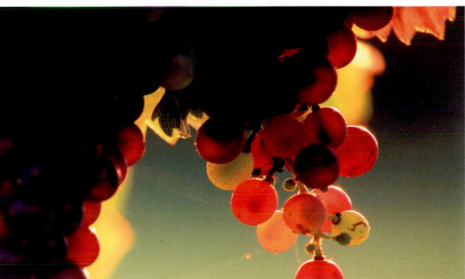

TOP Back lighting makes these grasses appear luminous.

MIDDLE Silhouettes are a common feature of back-lit scenes.

RIGHT Back lighting is an effective way of revealing translucency.

Lighting from above

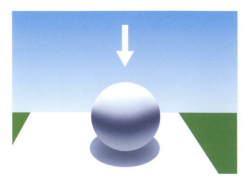

Top lighting is a slightly more unusual situation, although it is common in overcast daylight. It can also be encountered in sunshine at midday, in some interiors and in other situations, such as stage lighting. In soft light it is an effective way of showing form. Under hard light it can lend an air of mystery by casting dramatic shadows that conceal most of the forms beneath them – people directly beneath hard lights will have black holes for eyes since their eye sockets will be in total shadow.

Top lighting is rarely used by artists, although that doesn't mean it shouldn't be. For overcast daylight it is the most realistic set-up, with the whole sky acting as a large diffuse light source. It's also an unusual lighting solution for more atmospheric situations, and the very fact that it's not often seen can be used to create an uncomfortable feeling.

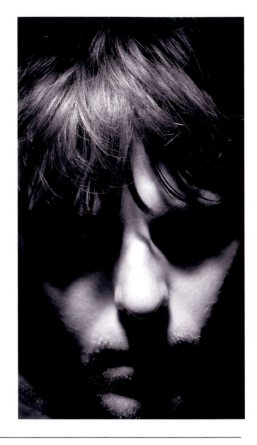

Lighting a figure from straight above can produce a brooding and menacing effect. It emphasizes bone structure and the depth of the eye sockets.

Lighting from below

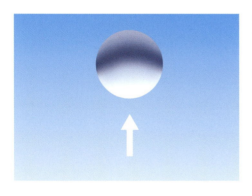

If lighting from directly above is rare, then lighting from directly below is even more unusual. In a natural context this might happen if you were standing over a camp fire, or holding a torch. Reflected light can also come from below – from water, for instance. It lends a strange appearance to even the most familiar things, since what is usually seen in light and shade will be reversed (think of a person shining a torch onto his face from below: the shadows appear to be upside down).

Again, the very rarity of this kind of lighting can be used to creative effect. We instinctively recognize when things don't look right, and you can use this to create specific moods by changing lighting to convey different emotions and provoke responses.

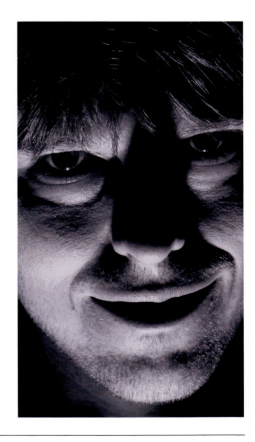

Lighting a figure from below creates a spooky look – even the highlights in the eyes look strange because of their placement. Note how the angle of the light also emphasizes the texture of the skin.

EXERCISE 2 Light and shadow on faces

Light direction has a major impact on a subject, both physically and in terms of its emotional impact. Let's look at a common subject – the human face – to see how the direction of the light can affect the resulting artwork.

It's worth experimenting with different lighting angles and set-ups to see how you can convey the mood you are looking for, as well as trying to find what might best suit your subject. Light and shade go a long way towards creating atmosphere: by using it alongside light quality (hard or soft) you can create any mood you desire.

Lighting set-ups

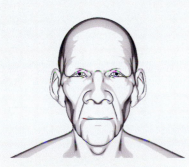

2.1 Front The first example, with no strong shadows, can be considered as the base-line art, or even how the subject might look in flat front lighting.

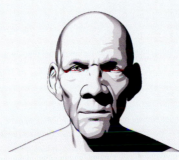

2.2 Side Add some light and shadow and the face becomes more solid and dimensional, its structure easier to see. The dark shadows also add some atmosphere and modelling. Note how the shape seems to be affected: the face appears to be narrower.

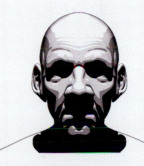

2.3 Above Lit from above, the face becomes sinister and the shape changes dramatically. The lighting you use will have a big impact on the perception of form – moving the light around affects the same form very differently, depending on the angle of the light.

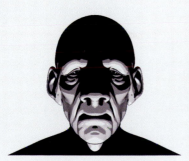

2.4 Below Lighting from below also looks sinister, and seems stranger because it's more unusual – we're much less used to seeing faces in this light.

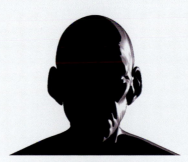

2.5 Behind Finally, lighting from behind completely obscures the features and is a great way of creating mystery and suspense.

3: NATURAL LIGHT

Natural light comes in a wide range of flavours, and the difference between them can be enormous. The source of all our natural light is the sun, which takes on different characteristics at different times of day and in different weather conditions, turning this single source of light into many different ones, ranging from hard and cold to soft and warm. This chapter looks at the various types of natural light and examines their properties and effects in detail.

This simple, back-lit landscape captures the luminosity of the sunrise and the way the light plays on the cloud formations and the sea. The landscape is of secondary importance; the real subject of the photograph is light itself.

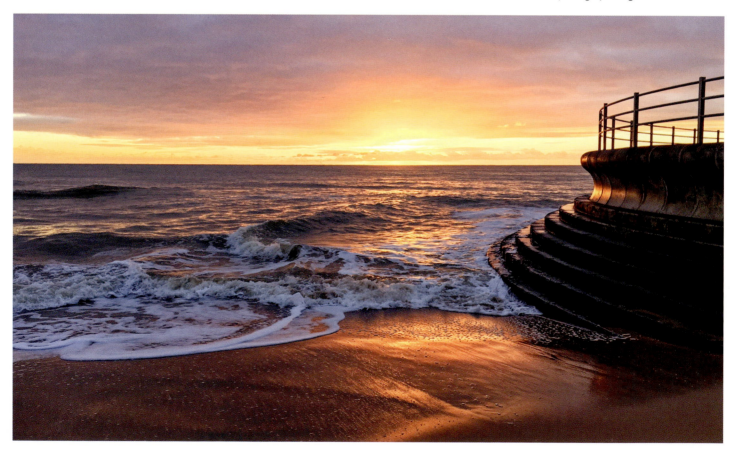

Mid-morning sunlight

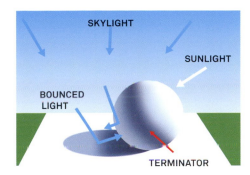

The above diagram represents sunlight at mid-morning or mid-afternoon, and is probably the most straightforward kind of sunlight in terms of colour and character. However, there are two major factors that affect the character of sunlight: scattering and cloud cover.

SCATTERING

The earth's atmosphere scatters the shorter wavelengths of light, which has the effect of creating the blue sky and of reddening the light from the sun itself. The more air through which sunlight has to travel, the more scattering occurs. This means that as the sun gets lower in the sky it has to travel through a thicker layer of atmosphere, thus causing more scattering at the beginning and the end of the day. Obviously, this means that sunlight has a very different character at different times of day. Special conditions occur when the sun is below the horizon, when skylight scattered from the sun is the only source of light.

CLOUD COVER

Clouds also have a major impact on both the colour and the character of sunlight. Clouds are translucent, which means that they let light pass through them, but in a diffuse manner. When light travels through a transparent surface, such as glass, the rays remain parallel; where a surface is translucent, the light that travels through it is diffused by the substance and the rays bounce around inside it, emerging from it in several directions. This is a similar phenomenon to the scattering of blue light by the atmosphere, except that in clouds it occurs across all wavelengths of light, not just the shorter ones.

The effect that this diffusion has on sunlight is to soften it, turning a small, hard light source (the sun) into a large, soft one (the whole sky). Colour is also profoundly affected by cloud cover, since clouds conceal the blue sky and the light coming from it.

Note how heavy cloud cover blocks the blue of the sky and softly filters the sun's rays.

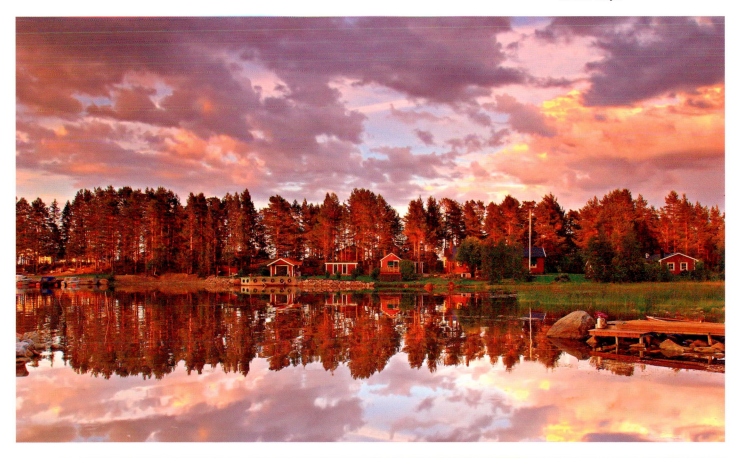

Midday sunshine

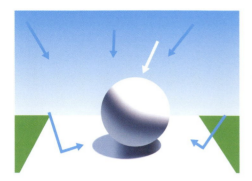

When the sun is at its highest point in the sky the light is at its whitest and strongest. Contrast is very high and shadows are very dark, so dark that film emulsions generally render them black – although it is still possible to see some detail in the shadows with the naked eye. For this kind of lighting to be recreated believably there needs to be very strong and high contrast.

The strong light has the effect of bleaching out colours, and these appear to be less saturated than at other times of the day. The strong contrast can make it difficult to create appealing images in this sort of light, although in situations where contrast is naturally lower it can work very well. Water, for example, can benefit from this strong light, and many images of tropical seas are taken at midday. In other cases the high contrast can be used to creative effect.

The small shadows and strong light aren't particularly revealing of form, and the low saturation is another drawback. Most photographers avoid using strong midday light, but that doesn't mean that these conditions are impossible. Going against conventional wisdom can lead to unusual and creative solutions.

This photograph makes use of the strong contrast of the midday sun to emphasize the contrast inherent in the scene. Using an infrared filter has heightened this effect. The image would probably not have been so appealing in colour.

This image is typical of midday lighting. The foreground sand is totally white and the shadow is jet black. The contrast is too high for the film to be able to reproduce the full range of shades.

Water photographs well at midday because the sunlight is at an angle that doesn't reflect towards us. This kind of light brings out the colour of the ocean very effectively.

Late afternoon/early evening sunlight

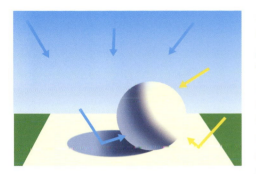

As the sun goes down, its light becomes progressively warmer, and by evening it has an obvious yellow cast. The colour of the sky also takes on a deeper shade of blue, thanks to decreasing light levels.

Evening light is generally considered to be extremely attractive, the warm colours and softer contrast being very easy on the eye. From about an hour before sunset this effect is at its most noticeable – photographers and filmmakers call this the 'golden hour' because the light takes on highly photogenic qualities. Colour saturation is very high and the colour of the light itself has a huge effect on our perception of the surfaces it touches, lending them a warm and rich appearance. By an aesthetically pleasing coincidence, shadows are close to the complementary colour of the highlights – the main light is a warm yellow, while the shadows are a cool blue. These pleasing properties mean that evening light is often seen in photographs, films and advertisements.

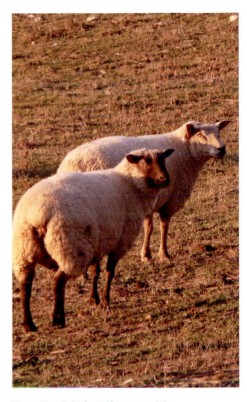

The yellow light from the sun and the blue fill from the sky are both visible on these sheep.

This photograph clearly shows the strong yellow cast of the evening sun on the chimneys of Battersea Power Station, London.

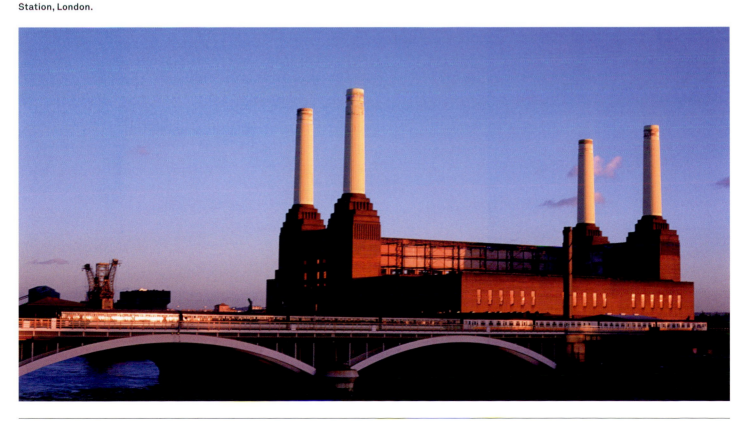

Sunset

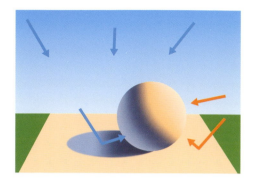

By the time the sun is about to set it has become a deep orange or red colour and its light has also become much weaker, which means that contrast is low. The weaker sunlight also means that skylight takes on a greater importance and shadow areas become a deeper and richer shade of blue. Shadows at sunset are very long and texture is very apparent.

The sky at sunset can be extremely colourful if there are any clouds. The clouds are now lit from below, taking on dramatic red or orange hues. These colours add some complexity to the colour of the skylight and, as a result, can affect the colour in shadow areas, sometimes turning them purple or pink.

Sunsets are also varied in terms of colour and atmosphere – if you observe several sunsets in succession, no two will be the same.

TOP Here the light of the setting sun is a deep orange, with the shadows turning purple as a result of the mixture of colours in the sky.

MIDDLE Sunsets are quite short and the light changes very quickly, so a scene such as this one will last for only a couple of minutes before the sun disappears below the horizon.

RIGHT Here contrast is low – the sunlight and skylight are very close in intensity as they shine on the rocks.

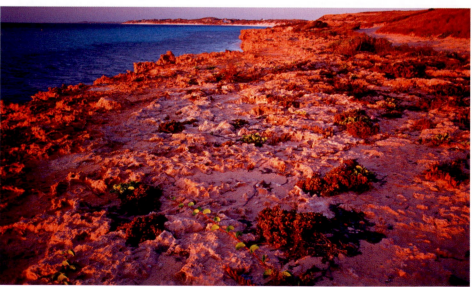

Dusk

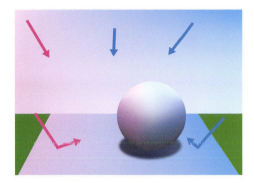

Dusk is a special time of day, with unpredictable but often beautiful lighting. Since the sun is no longer above the horizon, the sky itself is the only source of natural light. As a result the light is soft, with little shadow and contrast, and the colours can be extremely delicate.

ALPENGLOW

After sunset on a clear day there is often a pink area in the eastern sky, a phenomenon called alpenglow. This is a frequent occurrence, but can surprise those who aren't used to noticing it. Alpenglow can cast a noticeable pink light onto surfaces that are reflective, such as white houses, sand or water. This pink light is too faint to affect darker surfaces such as foliage, so the land will often look dark.

However, alpenglow isn't a guaranteed feature of the sky at dusk. Sometimes the eastern sky is blue. There is always a yellow or orange glow to the west where the sun is illuminating the sky from below the horizon. The glow from the sun in the west can last for over an hour after sunset, although the colour in the eastern sky is much more short-lived and changes very quickly. It is worth noting that the western sky can also be pink, as well as yellow, orange or red.

From indoors the sky can look a deep and vivid blue at dusk, especially as it contrasts with the orange tungsten lighting that is found in household lamps.

In overcast conditions the skylight is always a deep, saturated blue (clear skies are needed to produce the pink light effect) and it is generally much darker, with night falling much more quickly.

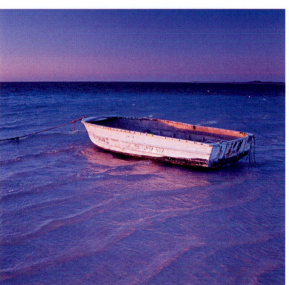

ABOVE The pink eastern sky is very obvious in this image. Note how dark the non-reflective surfaces, such as foliage, become, whereas the more reflective surfaces, such as the cranes, still look quite light.

FAR LEFT In overcast weather the dusk light is a deep saturated blue.

LEFT The delicate pink dusk skylight and blue from the water are reflected on the boat.

Open shade

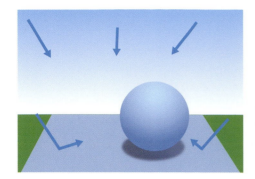

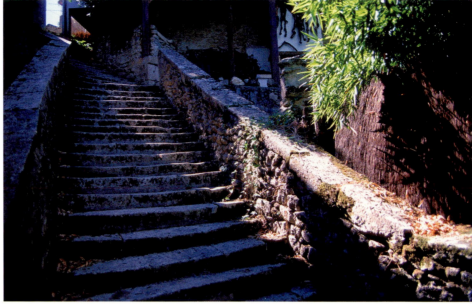

In open shade the sky becomes the main source of illumination, and as a result the light has a strong blue cast. The light from the sky is diffuse with soft shadows. Without the atmosphere to scatter light there would be no illumination here – if you were to stand in a shady area on the moon it would be pitch black.

Light in open shade can also be reflected from the environment, from nearby walls, for example. Foliage and other surfaces can also reflect light into shady areas, with resulting effects on the colour of the light. If you stand in a dense forest where the sky is hidden but leaves are reflecting light, then the colour of the light will be green. The same effect can be seen between trees and grass.

ABOVE The strong blue cast of open shade is clearly visible on these steps. Although the light is diffuse it still has a strong direction and is coming mostly from above, the other directions being hidden by walls.

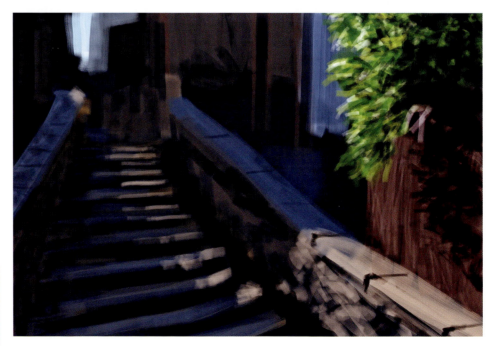

BELOW This plant looks blue in the diffuse light found in open shade.

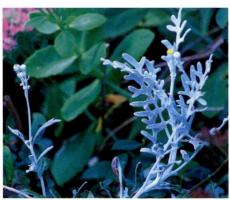

ABOVE Compare this sketch to the reference photograph above to see how details are ignored in the sketching process. The stairs have been reduced to their most basic forms, and the render is bold and quick. What is actually painted is the light and the colour.

Overcast light

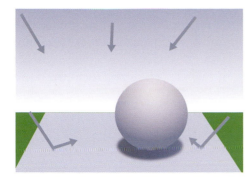

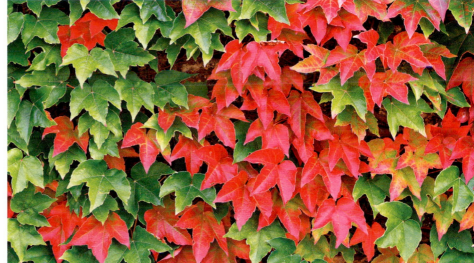

Overcast light comes in a few varieties, depending on the thickness of the cloud and the time of day. It can be quite beautiful, with several attractive qualities. Since the whole sky is acting as one light source, the light is soft and diffuse, with soft shadows. Contrast is low and colour saturation is usually quite high.

Colour is dependent mostly on time of day. Colour temperature charts often claim that overcast daylight is blue, and the thicker the cloud, the deeper the blue. However, if the sun is high, the light can appear to be white or grey, and the thicker the cloud, the whiter the light. It's only when the sun gets lower in the sky that overcast light becomes bluer, and the lower the sun goes, the more obvious this becomes.

Overcast light is often perceived as being dull, but it can be beautiful too. Because it is soft it is very flattering, and it can be used to great effect to show colour and texture. Reflective surfaces can also look very appealing in this kind of light, since the white sky creates broad and soft reflections of itself. This is most often seen in water but also on other surfaces, such as the metal on cars.

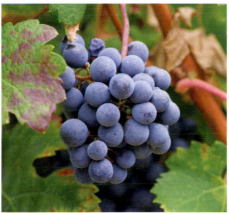

ABOVE The diffuse light shows the form of these grapes but the contrast is sufficiently soft that very little is lost in total shadow. Again, the colours are very saturated.

TOP Because of the low contrast and relative neutrality of overcast light, these colours appear very saturated. Notice the large, soft highlights in the red leaves created by the reflection of the sky. On a sunny day these highlights would be much smaller and harsher.

MIDDLE An overcast sky creates beautiful silvery reflections in water. One of the secrets to getting good images on overcast days is to keep the sky itself out of the picture.

Bright overcast light

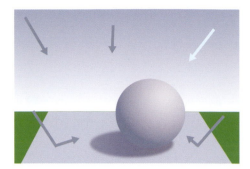

On days with thinner cloud it is possible to get a little directional sunlight coming through. This creates stronger shadows, which can still be soft, as long as there is cloud in front of the sun. Bright overcast light is an almost ideal compromise between the strong contrast of sunshine and the relative dullness of heavy cloud.

Thinner cloud cover means that the sky can have a lot of texture, whereas on days with heavy cloud cover it tends to look a solid white or grey. Varying cloud thickness or small gaps between clouds can also help to introduce colour into the sky, with blue skylight and yellow sunlight reflecting onto the surface of the clouds. Colours in the sky can vary hugely when cloud is thinner, and the sky can often be very striking when cloud is thin or broken. Another factor influencing cloud colour is distance – distant clouds can appear yellow or even orange because of light scattering, even in the middle of the day.

Bright overcast light has a stronger sense of direction than the more diffuse light from heavy cloud cover, but shadows are still filled in by the surrounding cloud.

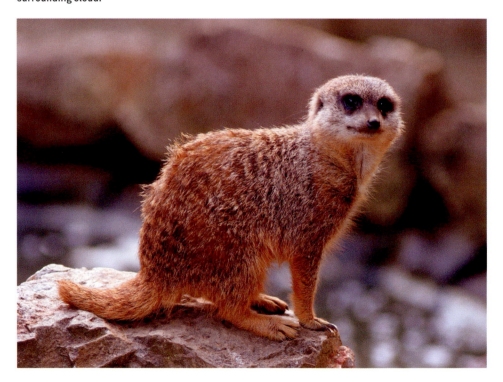

Here the stronger light from the sky is bright enough to outline the meerkat but the shadow beneath him is still soft because the sunlight is being diffused by cloud. Note also that there is no blue in the shadows since there is no blue sky.

Broken cloud and dappled light

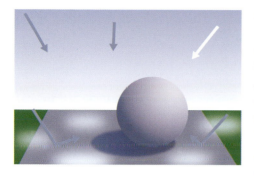

It is also fairly common to come across mixtures of light and shade in natural environments. Although they have quite different characteristics they are grouped together here.

BROKEN CLOUD
With broken cloud you get a type of light that is different from pure sunshine or overcast light. The blue fill light from the sky is absent yet the sun can shine brightly if there is a gap in the clouds. Clouds will cast visible shadows on the landscape and there will be patches of sunlight in between these shadows. Contrast can be high, and the grey skies will provide a dramatic backdrop to surfaces that are in sunshine, with the difference between the bright light and the gloomy background creating interesting juxtapositions.

Again, skies in this light can be very colourful, with many factors influencing the colours: time of day, thickness of the cloud, gaps between the clouds, distance, and so on. Colours can range from many shades of blue through yellows, oranges and greys. Light can change fast as the clouds move across the sky, with sunlight appearing and disappearing from moment to moment.

DAPPLED LIGHT
Dappled light, such as that found under trees in sunshine, is another mixture of light and shade commonly found in nature. It is a high-contrast light, and in full sunlight it can be very bright in contrast to the shade around it. Most cameras will not be able to capture the full range of tones that exist in dappled light, although they may be visible to the naked eye.

LEFT The camera can barely handle the range of contrast provided by this lighting.

BELOW LEFT The highlights in dappled light are very bright – in parts of this photo they are pure white.

BELOW Sunlight against a dark, cloudy backdrop creates a dramatic mood.

Night light

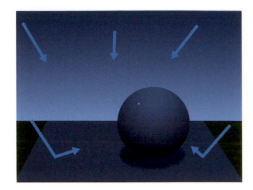

Although the sun is no longer in the sky at night, the sky itself generally has some light in it. This light might come from sunlight being scattered through the atmosphere, or from moonlight. Stars are too faint to cast any noticeable light.

The key point to remember about lighting a night scene is that the sky will always be lighter than the land – unless, of course, there is artificial light on the landscape.

Look at the two landscape silhouettes below: the first one is the correct one; the bottom image is a physical impossibility because the light on the landscape would have no source.

MOONLIGHT

Moonlight is reflected sunlight and obeys the same rules as sunlight. When the moon is near the horizon it has a red or yellow colour, but as it gets higher in the sky it becomes whiter. The surface of the moon is almost colourless, and photos of the moon landings can look as if they were taken in black and white.

Light from the sky is diffuse and soft. The main difference is that moonlight is obviously much fainter, so the ratio between the hard moonlight and the soft skylight will be different than in daylight. Another thing you should be aware of is that the moon is quite small when viewed with the naked eye, and it can often be tempting to make it much larger than it appears in real life.

Our eyes have very little colour sense in the dark so our perception of night is colourless. You can expose a photo at night that will look as if it was taken in the daytime if you leave the shutter open for long enough. Even short exposures at night have far more colour than the naked eye can perceive.

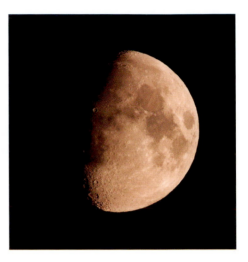

The moon has a slight red or brown cast here because it is low in the sky. At its zenith the moon is white and grey.

Note the lightness and colour that is present in the sky. In a photograph colour looks stronger than it appears to the naked eye.

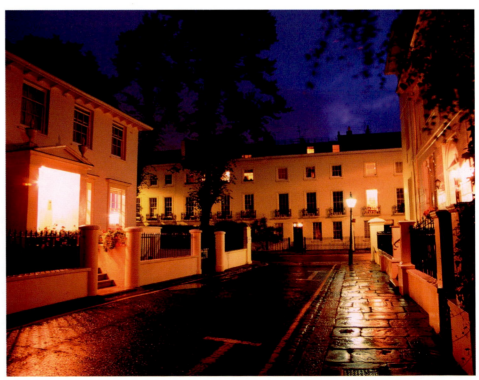

Colour in the sky

LIGHT POLLUTION

Another factor to consider with night scenes is light pollution. In the UK, no matter where you are (even in the countryside, miles away from any town) you can see city lights glowing in the sky somewhere, or reflecting back down off clouds with an orange glow. You have to go to some extremely remote places to avoid this in the modern world. In filmmaking, a classic way of shooting night scenes is to shoot in daylight but underexpose and use a strong blue filter to create the illusion of night.

The sky is often very colourful. If you look at it every day you will see that it can produce amazing and complex ranges of different colours. Many factors will influence the colours you see in the sky or in clouds. As well as time of day and cloud cover, the thickness of the clouds and the space between them are important. If the cloud is of uneven thickness, or if there are small gaps between closely spaced clouds, there will be variation in the amount, colour and quality of light in the sky. This creates texture and a great deal of unpredictable variation.

Natural light, and the sky in particular, almost always has some colour, even on the bleakest day. The sky is a constant diffuse light source during the day, no matter how bright or dim the sun is.

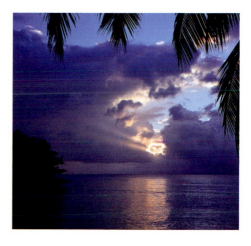

Golden sunbeams breaking through the clouds are caused by particles in the atmosphere catching the light.

Where there is no artificial light the landscape elements are very dark compared to the sky. Note too how the roofs in the foreground are still reflecting skylight, despite the darkness.

The sky is always changing and unpredictable. Here the distant rain looks pink. This is because the evening sun is behind it.

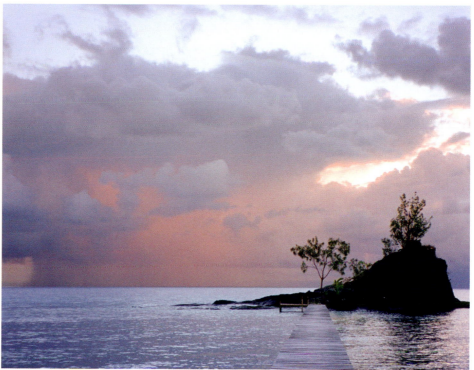

Atmospheric effects

Light interacts with the atmosphere if there are any particles suspended within it that reflect or scatter light. Particles of dust, water or pollutants catch light and give a sense of volume, creating sun rays, haze or fog.

Haze is almost always present in the air, and it is what causes the perception of aerial perspective: things that are further away from us are obscured by haze and look fainter, bluer and lower in contrast because the light reflecting from them has been slightly diffused by haze.

Fog is very similar to haze, only thicker. It is a great diffuser of light, and in thick fog the light becomes so scattered that it has equal strength from all directions. When taking photos in thick fog a camera meter can give exactly the same reading whether you point it up, down or to one side. Haze is generally white or light blue, depending on the weather: it is usually blue if it's sunny (because it's reflecting the sky) and white if it's cloudy. Fog is white (like clouds) but can also take on any colours that might be shining on it from the sky or the sun, so in practice it can look blue or even yellow or orange.

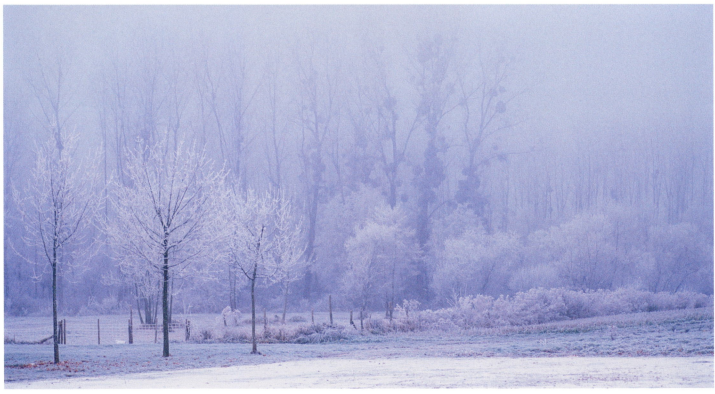

LEFT This ground fog is a deep blue because it is reflecting the blue sky above it. The trees are shading it from the sun's glow, otherwise it might be yellow or orange.

BELOW This winter scene is shrouded in heavy fog and this creates very diffuse lighting. There is no shadow whatsoever beneath the trees.

Water

Water, being a common feature of the landscape in the form of rain and dew, lakes, rivers and the sea, has a big role to play in how light reacts with the world. Water changes any surface that it sits on because it is highly reflective and causes strong specular highlights. Dew in grass, for example, can cause thousands of little highlights as it catches the morning sun, with each drop acting as a tiny lens. Water also reflects light back up into the landscape, so there is always reflected light by the sea.

BELOW LEFT The water on this lake acts like a mirror, reflecting the light.

BELOW RIGHT The sticky liquid on these berries gives their surfaces strong highlights that accentuate the texture of their skin.

BOTTOM LEFT Small drops of water will cause a multitude of specular highlights on a surface, even in overcast light.

BOTTOM RIGHT The strong mirror-like reflections on this pavement tell us that it is wet.

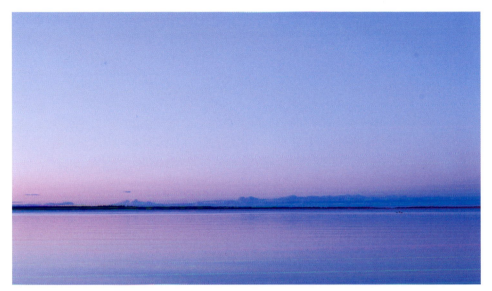

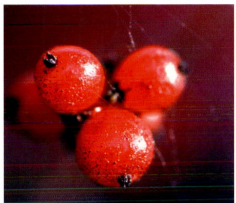

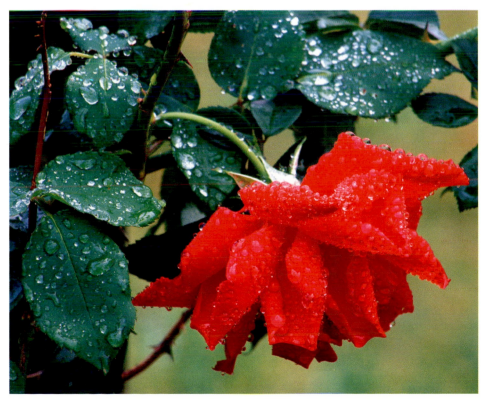

Final note

Natural light is a complex and constantly changing phenomenon, and careful study of its ever-changing nature will be rewarded.

The guidelines here will help you to understand it in different conditions. By making your own observations and applying them to your work you can steer clear of obvious mistakes and clichés. Reality is only a starting point and there is always room for interpretation and exaggeration.

Sometimes common wisdom or rules are passed down unthinkingly – for example, warm light should have a cool fill. This can be true in natural light, with yellow sunlight and blue shadows, for instance, but there is a physical reason for this and the rule should not be followed blindly. In other circumstances it might not be true, for example, where there is broken cloud.

The same applies to the theory that shadows should be in a colour that is complementary to the main light. This can be a common perception as the brain can fill in the shadow with the complementary colour, even if it's not really there (something a photograph should be able to establish easily). Only apply this theory if you have observed it yourself, or if you want that particular effect – not because it's a rule.

EXERCISE 3
Light in the landscape

The best way to learn how natural light works in landscapes is to do series of quick studies, either from life or from references. The goal of these should not be to capture every detail, but to concentrate simply on the mood and lighting – if you work quickly you will be able to concentrate on getting the light right, leaving out the details.

The more of these studies you can do the better, since there is no substitute for real experience in the attainment of artistic ability and knowledge. If you can produce a series of 20 or more of these studies you will see a major progression as you go along. The examples shown here were each executed in around an hour or less.

These quick sketches will give you an idea of what to aim for. Examples 1 and 2 feature a heightened and more saturated colour palette to convey a slightly fantastical and idyllic feeling. In the third example the colours are muted and closer to reality.

These decisions are subjective ones, based on the kind of mood you are trying to achieve, but either approach is acceptable – it's up to you.

3.1 Here you can see how the detail has been reduced down to the absolute minimum in order to concentrate on capturing the colours and atmosphere. By keeping the sketches very loose you will be able to concentrate on the light itself.

3.2 This impressionistic sketch is based on a photo of a volcano. The aim was to capture the drama of the lighting and atmosphere. There is no detail at all – it is all about light and colour and mood. The lack of detail helps convey the misty atmosphere and bright back lighting.

3.3 Here the aim was to convey the sense of haze and atmosphere in a woodland. Note how important atmospheric effects are in these sketches – they become one of the main means of describing the conditions.

3.1

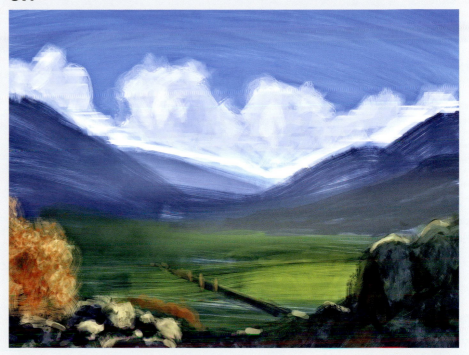

3.2

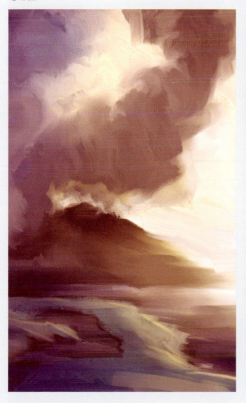

3.3

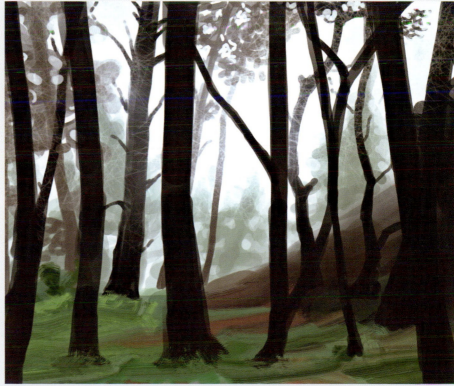

4: INDOOR AND ARTIFICIAL LIGHTING

Light indoors has a very different character from that found outside, the biggest difference being that falloff is a significant factor indoors. Falloff affects all man-made lights and light coming from windows, but in sunlight (either direct or diffused by cloud) it is not noticeable because the sun is so far away. When human beings are in control of the light source there is an added twist in that the light is often designed for a specific purpose. For instance, household lights are designed to give off appealing, generally diffuse light, whereas office lighting is more functional and cost-effective, and tends to be harsher.

A scene from Tim Burton's animation *The Corpse Bride*. Note the soft yellow light cast by the hanging lamp, causing dappled patterns on the wall.

Window light

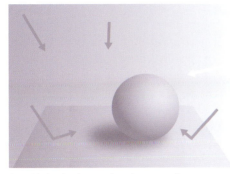

Sunlight indoors is almost always diffuse, bouncing between walls, floors and ceilings. Direct sunlight can get in through windows but, because of the comparatively small size of windows in relation to walls, much of a home will never receive sunlight that hasn't been reflected by one surface or another.

Window light is how we generally see natural light indoors. Since the window itself is the effective light source this means that the light is quite soft. Window light is attractive and very photogenic. If there is only one window then contrast is relatively high, despite the soft light source. With multiple windows contrast is lower as there will be more fill light.

The colour of the light is dependent on several things. The weather will affect the light coming through the window. If it is overcast, the initial light will be white, grey or blue. In sunny conditions it will be either blue skylight or white, yellow or red sunlight (depending on the time of day). Once the light has come through the window it will be affected by the surfaces in the room from which it is reflected. Wall, floor and furniture colours will all influence the light as it bounces around.

This means that to portray window light convincingly you need to think carefully about all the possible permutations and plan the strength, colour and contrast thoughtfully. The simplest set-up would be an overcast day with white light coming into a white room from one large window; you can then plan any variations using this simple model as your starting point.

NORTH LIGHT

One very famous type of window light is called north light, the light provided by a north-facing window. In the past artists didn't have reliable artificial lighting, so by having a studio with a window that faced north it was possible to have a fairly constant and consistent light throughout the day. The reason is that (in the northern hemisphere) the sun is always in the south, so only diffuse light from the sky will shine in through a north-facing window – soft light with no strong direction or shadows. The main qualities of north light are the same as any window light without direct sunlight. Although north-facing rooms are dim owing to lack of sunlight, the light is quite pleasing.

TOP LEFT This room is lit by diffuse light coming from the windows. The blue tint that is visible in the light is due to the blue sky.

LEFT With some direct light coming into the room from the evening sun, the light takes on a different colour and there is much greater contrast between light and shade.

Household lighting

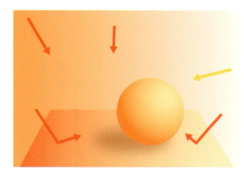

Most artificial lights indoors are diffuse – this is the purpose of the lampshade – in order to soften the light and the shadows it produces. The major exception to this is spotlights, which produce hard lighting. However, lighting designers will generally use multiple spotlights so that there isn't just one hard light but several, which together will soften one another's shadows yet still create a multitude of highlights.

Tungsten has historically been the most common form of indoor lighting, although it is gradually being replaced by more efficient lighting technologies, some of which emulate the colour of tungsten and some of which are closer to white.

The colour of tungsten lighting is a strong yellow/orange (see Chapter 1, page 15). This is because it is easy to manufacture light bulbs that emit this colour, and since our brains have the capacity to filter out the orange colour, we perceive it as being white. If you are photographing, drawing or painting a tungsten-lit interior it is usually more realistic to depict the light as being whiter rather than more orange. Your own perception, rather than absolute reality, should be your benchmark to follow. Photos or drawings that look bright orange might look less convincing, despite being more accurate.

However, the quality of tungsten lighting is varied and less predictable, since there are many different approaches to lighting interiors. In ordinary households most lights will be diffused by the use of a lampshade, making the effective size of the source bigger and softening the light.

FUNCTIONALITY

Lighting in the average house will vary from room to room, with the function of the space dictating the quality of the light. On the most basic level a utility room or a garage might have a single bare bulb, providing hard, unattractive light. Little time is spent in rooms like these, so functionality will take precedence over aesthetics.

In a room where you might spend a lot of time, and where quality of light might be considered important in order to create a pleasant and comfortable atmosphere, you are likely to find a more complex and attractive lighting scheme. In a sitting room (which might be the centrepiece of a home) you might find a large number of lights, used in a well-considered combination to create a pleasing ambience.

Function will also play an important part in other areas of a typical home. In a bedroom you would expect to find bedside lights because they are convenient for bedtime reading or for getting up in the dark. In a kitchen you might find spotlights designed to light up the cooking area or work surfaces, and bathroom cabinets and mirrors might also have dedicated lighting for functional purposes.

Apart from the most basic situations, most household lights will combine function with light quality. The most common accessory to a household light is the lampshade, which comes in many forms, all designed to soften the light to some extent. A lampshade will hide the blinding glare of a bare bulb and soften the hard shadows created by a naked light source.

It is easy to observe just how yellow household tungsten lighting is when looking at a lit-up house from the outside. Inside the house, our eyes perceive such light as being much whiter.

LIGHT SOURCES

The next important element to consider is that most interiors will use a number of light sources, which will further soften the light and shadows. The light from different rooms will spill over into adjacent spaces, and most rooms will have more than one light in them. Typical examples might be sitting rooms with four or five different lights used to create small pools of attractive light, or a modern kitchen, which might have rows of recessed spotlights in the ceiling.

Multiple lights used in this manner will create uneven and interesting lighting across the room and will cast multiple shadows, often with different levels of hardness or softness. The other very obvious result of having a number of light sources is that reflective surfaces will have multiple highlights, one for every light. It is also possible that the lights will be subtly different in colour and intensity, because bulbs get dimmer and redder as they get older.

Finally, certain other household devices can emit light, including computers, televisions, microwave ovens, cookers and a multitude of other appliances.

Study a number of interiors for yourself – this subject is limited only by human imagination and there are infinite variations on the theme.

Interiors typically use a number of lights to create atmosphere. Note the various methods used to soften the light here, including lampshades and bouncing light off the wall. Using a mixture of hard spotlights and diffuse lights creates a more interesting lighting scheme.

Commercially designed interiors

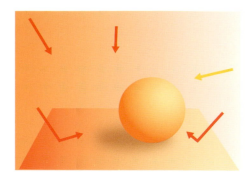

As with ordinary household lights, this kind of lighting is very varied and used primarily to create mood and direct the eye. It is often designed with great care, so it will require careful study to recreate what the designer has aimed for. Make your own observations of various settings, taking photographs for reference.

Restaurants generally have a number of low, soft lights to create atmosphere. There might also be quite a mixture of different kinds of lights, from spotlights to pick out the flowers on the table, to candles on the tables themselves. No two restaurants will be the same, so expect a great deal of variety from one to the next. Observing restaurant lighting carefully is a good way to learn how mood and atmosphere can be created with interior lighting.

One important detail to note when recreating the atmospheric lighting you might find in a restaurant or bar is that the relatively large numbers of lights used will also create many reflected highlights – these will be visible in all reflective surfaces, from cutlery and plates to people's eyes. As with household lighting the different sources will vary in colour and intensity, creating pools of light across a room.

Shops have different lighting needs, and although atmosphere is still important, cost and visibility are the main criteria. Most mainstream stores will be brightly lit with strip lights to create a bright and clear environment, perhaps with extra lighting to pick out specific displays. If you are trying to recreate a specific environment think of the function of that place before trying to recreate its lighting.

TOP The interior of this bar utilizes several lights to create atmosphere, including fairy lights and bright spotlights.

LEFT In this shop you can see that the lighting has been designed to provide bright and even illumination throughout, with the displays having concealed spotlights within to highlight the showcased products.

Fluorescent lighting

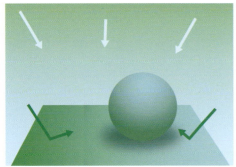

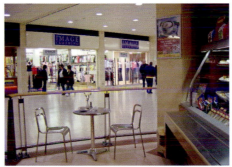

ABOVE This photo was taken with daylight-balanced film under fluorescent strip lights – you can see the strong green cast of these lights.

LEFT This image of a shopping centre with bright lighting has been colour corrected, but the slightly green tint from the lighting is still visible. Note the multiple shadows under the chairs, which come from multiple light fixtures.

Fluorescent lights are primarily used in situations where cost is a factor – their colour temperature is usually greenish, and although the brain can compensate for the white balance, we still perceive the light as being quite ugly. This kind of lighting is commonly found in offices, stations, public buildings and anywhere that needs to be lit economically.

Fluorescent lights are often used to light relatively large areas with many individual lights, so there will be complex overlapping shadows and multiple rectangular highlights. The density of lights will dictate the brightness of the lighting: shops will use many lights to create a bright environment, while more spartan spaces, such as car parks, will use fewer and will be darker.

Mixed lighting

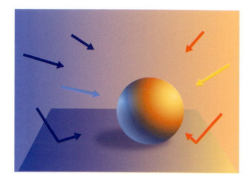

It is very common to see a mixture of natural light and artificial light, both indoors and outdoors, especially at dusk and at night. This can lead to interesting mixtures of colours and intensities, especially since natural light and tungsten light often have complementary colours in the form of blue and orange.

Any object near an uncovered window in the evening or at night will have some mixture of natural and artificial light on it. This kind of lighting is also commonly found outdoors – things illuminated by street lighting usually have some natural light as fill. Lights on buildings can also have very interesting colours and create striking contrasts with natural light coming from the sky.

You can use real-life lighting schemes to give a realistic feel to imaginative artwork. Note the similar colour schemes in the photograph above and the illustration below: both use the classic warm/cool colour contrast that is typical of artificial light mixed with natural evening light.

ABOVE Interesting colours are created by design in urban settings – the warm lights on the Houses of Parliament were most likely designed to complement the natural evening light.

RIGHT Mixed lighting can be very evocative and inspirational. Here it has been used to create a magical atmosphere.

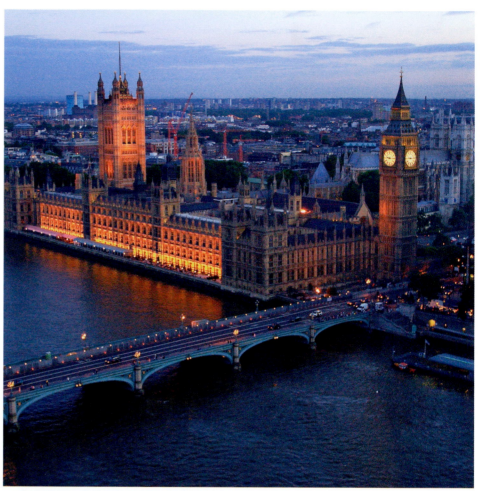

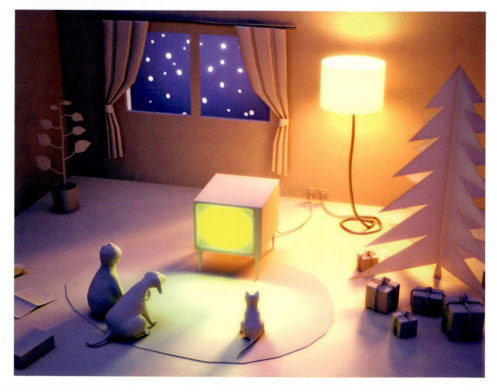

ABOVE This scene mixes warm artificial light with cool natural light from the night sky.

RIGHT Here the mixture of colours looks positively alien, with the green of the fluorescent lights in the windows mixing with both tungsten lighting and skylight.

Fire and candlelight

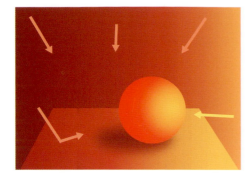

Light that comes from a flame is even redder than incandescent light from light bulbs – its colour temperature is so low that the brain can't compensate for it and we actually perceive it as being orange or red.

These types of light source are often placed much lower than incandescent lights: fires are usually at ground level and candles are placed on tables or other furniture, whereas bulbs most often light from above. This will have an obvious effect on everything from the way that light strikes various surfaces to shadow and highlight placement. It is worth remembering that this type of light source is often moving, since light from fire and candles flickers.

ABOVE Candlelight is very red. The actual colour temperature has been toned down here to make it look more natural. The brain can't really compensate for such strong colours, so we perceive the light as being warm.

RIGHT A playful take on the red light from fire and flames.

Street lighting

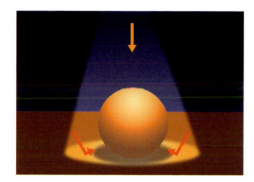

Street lights are a deep orange and they have a very narrow spectrum, which is why they can't show any other colours. This makes everything under them appear to be a very monochromatic orange colour.

Objects between two or more street lights will cast multiple shadows. The pool of light beneath them is usually quite small, and fades into darkness fairly quickly, making streets at night very high in contrast.

Photographic light

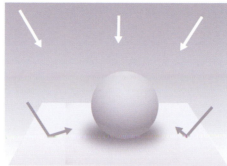

A full explanation of photographic lighting is far beyond the scope of this book, but is mentioned briefly here so that photographic references can be used wisely. Although many types of lighting are used in photography, that most commonly found in portrait and product photographs is very soft light from a diffused flash.

This kind of light is easily recognized by the absence of shadows, so if your photographic reference features this sort of lighting, take it into account and adapt it to your own requirements. This applies to any lighting found in reference material.

Special cases

It is easy to take lighting for granted and not notice how it behaves, even though we see it all around us all the time. Looking and genuinely seeing seems to be the main hurdle – it is actually quite easy to reach an understanding once this crucial first step has been taken.

With the knowledge gained in these chapters, it should be possible to work out how light behaves in situations that aren't specifically explained here. For instance, you may need to work out how to light an underwater scene on a tropical reef. Where would the light come from? How would the light react in this environment? What colour would it be? How much reflection would there be? What about diffusion, clarity and shadows?

Use the information here as the launching pad for your own observations. It is easy to stick to formulas, but you will get better results from using observation and analysis to come to your own original conclusions.

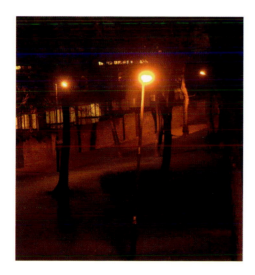

Everything except the grass is orange under the street lights. The shadows point in various directions because of the multiple lights, and contrast is very high, without any fill light.

This soft, shadowless light with broad highlights is typical of contemporary product and portrait photography. It is created using very big softboxes, which act as large diffuse light sources.

EXERCISE 4
Mixed lighting

When it comes to creating atmosphere, mixed lighting is very effective for several reasons. You can create good colour contrasts, including contrasting complementary colours, which will lend a great deal of aesthetic appeal to the lighting. You can also use the different light sources to create emotional impact, by contrasting warm and cool colours, for instance, thereby suggesting conflicting emotions.

Lighting is a useful way of conveying a vast and almost subliminal amount of storytelling information in your images. As you will see in Part 3 of this book, it plays a key role in conveying moods. You can see the subtlety with which it can be applied: although this image has a scary subject matter it is essentially humorous, and all of these nuances are conveyed through the lighting and the colour scheme.

A more serious piece, one that was intended to be really frightening, would use a darker and more muted palette with far darker shadows, while an image intending to convey a less sinister brand of humour would probably use a brighter and lighter palette altogether. If you think carefully about the lighting in your images you will be able to convey a lot of meaning and emotion.

Interiors offer a huge amount of scope for this kind of manipulation since you are able to mix different kinds of light sources, such as the moonlight and candlelight in this example – but there are many more possibilities available to you.

The cold blue window light is used against the warm orange light from the lamp to create a cosy yet spooky feel. The contrasting colours are complementaries, which helps to create a heightened and exaggerated palette that suits the cartoon style of this scene perfectly.

The emotional message of each light source also helps to further the story within the picture: the lamp by the bed is warm and comforting whereas the blue window is cold and sinister – the bedside lamp represents warmth, comfort and safety, whereas the moonlit window is the unknown. Despite these psychological connotations, the colours of these light sources are based on reality, if a little exaggerated for emotional impact.

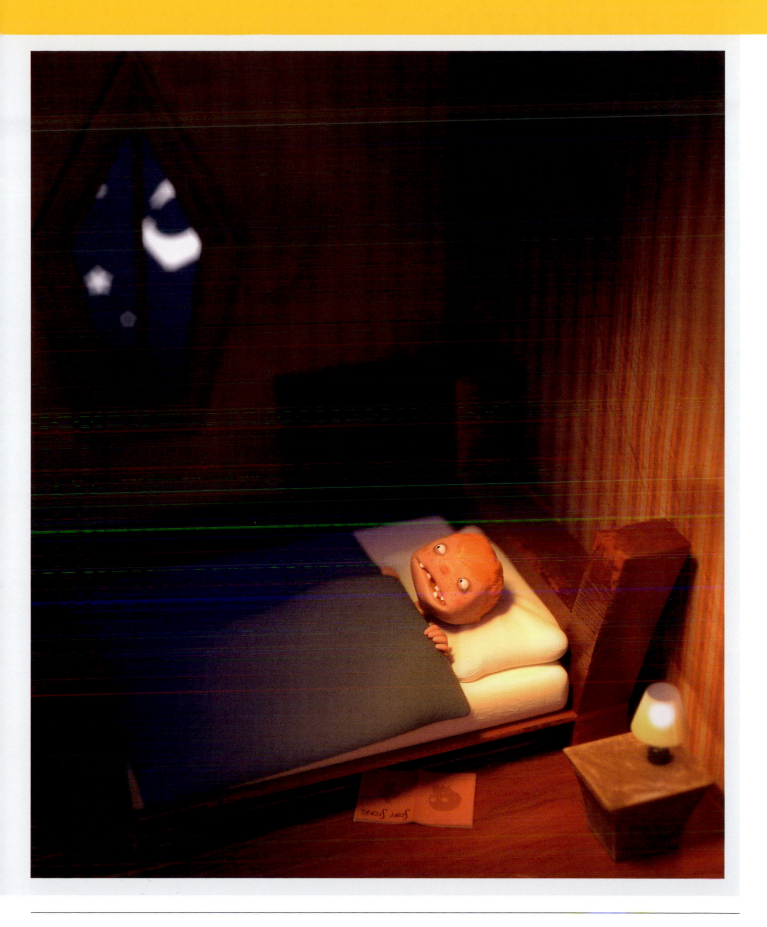

5: SHADOWS

There are two kinds of shadow: form and cast. Form shadows are the shaded areas on a surface where a light source cannot reach. Cast shadows are what we typically think of as shadows: the shadows projected by an object onto a surface (such as the ground) when the object comes between the light source and the surface. Shadow plays an important role in your artwork, giving it solidity and form as well as creating drama and suspense.

Shadow can be used to create a sense of realism, giving objects weight and presence or, as here, to create atmosphere.

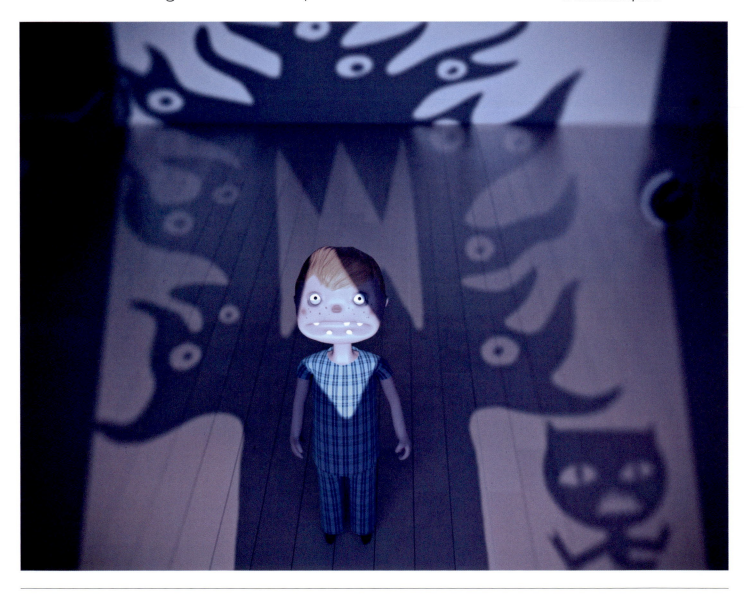

Types of shadow

If we were somewhere where ambient and reflected light didn't occur, such as space, the values of form shadows and cast shadows would be identical: absolutely black. However, here on earth things aren't that simple – the atmosphere acts as a giant diffuser, scattering light everywhere, and our world is also full of reflective surfaces that scatter this light even further. This means that shadows are, in most cases, filled with some secondary light, and generally more of this secondary light will illuminate form shadows as opposed to cast shadows. The diagrams demonstrate why this happens.

When light bounces off a large area, such as the ground, the reflected light is effectively coming from a large and therefore bright source. This means that the form shadow on the sphere is getting quite a lot of fill light coming from the ground, as well as light coming from the atmosphere.

Because the sphere itself is much smaller than the ground, it reflects less light. The cast shadow therefore gets only a small amount of fill light from the sphere, and is mostly lit by

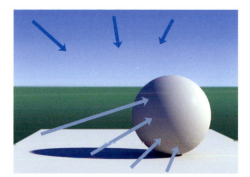
Form shadow

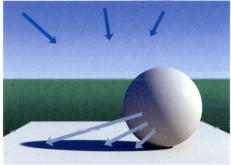
Cast shadow

the atmosphere. Notice also that the terminator is dark and saturated.

This means that in ordinary outdoor situations, cast shadows will usually be darker than form shadows. This is just a rule of thumb, and there will be occasions where some source of light might be providing more fill to the cast shadows than the form shadows, therefore making them brighter.

Form shadows give objects depth, especially with side lighting, and really help to convey the form of an object. The absence of form shadow is why frontal lighting can look so flat. Form shadow also reveals texture. The 3-D renders of a tree trunk, below, illustrate these points clearly: the second image has more depth, and the trunk

looks more solid and dimensional. The texture is also greatly emphasized by the stronger, more directional light. Thus the form shadow plays a very important role in conveying both the form and the texture of an object.

Here is a rare case of the form shadow being darker than the cast shadow. This is because there is more reflected light filling in the cast shadow.

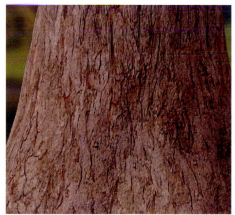

This tree is lit by a large, diffuse source light, such as occurs on an overcast day, making the form shadow soft and gradual.

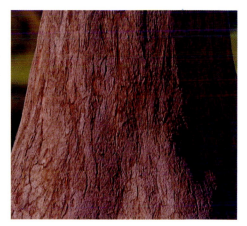

Here the tree is lit by a harder light (simulating the evening sun), giving a harder edge to the form shadow. There is also much greater contrast between the lit and shadowed sides.

AMBIENT OCCLUSION

In 3-D imaging another layer of realism can be added to rendered images by creating an ambient occlusion pass.

This is created by darkening surfaces that are adjacent to others, and creating a shadow around the area where they meet, simulating the effect of a large, diffuse light source. Although there is no actual lighting in the scene below, the technique creates a sense of depth and solidity, illustrating perfectly how shadows contribute to the illusion of depth and form. Darkening areas where surfaces meet in this fashion will really help any image, whether it is a 3-D render or a painting.

In diffuse lighting this is the main way we have of reading forms: as objects get closer to each other, less light is available from the environment and so the surfaces darken. The form of the grapes (right) is perfectly defined by this shadowing. It is also worth noting how the more obstacles there are in the path of the environmental light, the darker the shadows become. The grapes that are behind or underneath others are darker than those that are on the outside of the bunch.

BASE SHADOW

It is also very useful to give objects a base shadow, since most things do not sit perfectly flush to the ground, but will have rounded edges at their base that will leave a gap where a shadow will form between them and the surface on which they are resting. This effect is most pronounced in diffuse lighting, where it will often provide some of the strongest shadow in the image.

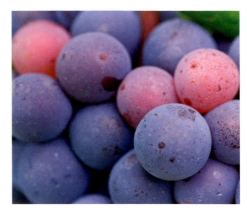

These grapes give the perfect illustration of how surfaces darken when they get close to each other.

This 3-D rendering has no light sources, but the inclusion of shadow creates the illusion of depth.

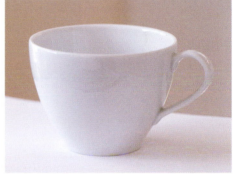

BELOW Note the base shadow below this cup, which is the darkest area in the whole image. If you look at the image on the left you will see a similar base shadow below the plant pot.

ABOVE Occlusion can occur over large surfaces as well as small ones: notice how the ceiling gets darker as the walls converge with it. This creates a gradient over the walls and ceiling that helps to convey the depth of the space.

RIGHT The effect simulated by ambient occlusion can be seen here. Note how the areas on the sofa and the plant that are in close proximity to others have shadows near the points of contact. This helps to give a sense of solidity and form despite the very diffuse lighting.

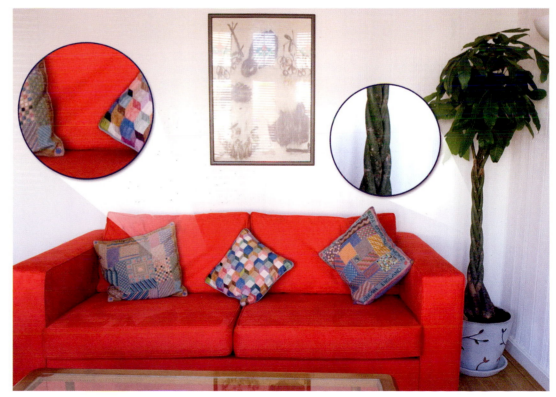

Light source

The most important factor in determining the appearance of shadows is the size and distance of the light source: a small or distant light will cast hard-edged shadows, whereas a large or adjacent light will cast soft-edged shadows. The reason for this is that the rays of light cast by the small or distant light will be more or less parallel, but in the case of the large and adjacent light there will be considerable overlap of the light rays.

This will affect form shadows, cast shadows and the texture contrast, as illustrated in the tree trunk render on page 53. Larger light sources provide soft, diffuse light, which creates soft, diffuse shadows. The quality of the light, whether hard or diffuse, has a big impact on the overall appearance of any scene, its effect on shadows being the most pronounced result. The overall aesthetic quality of any image will be greatly influenced by the quality of the light, and by the resulting shadows. Many studio photographers make use of large softboxes to create soft lighting, since it is very flattering and avoids strong contrast and dark shadows.

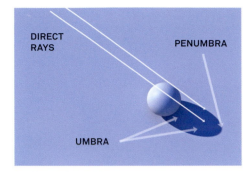

Small or distant light source

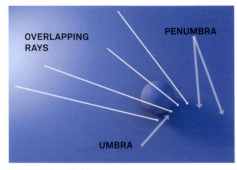

Large or close light source

When recreating natural light, the sun is a very distant light source, which casts hard shadows, and the higher up the sun is in the sky, the harder the shadows will be. There is some softening of the edges on the sun's shadows, as it does cover about half a degree in the sky: the further the shadow is from the base of the object, the softer its edge becomes, and as the shadows get longer when the sun is lower in the sky this softening becomes more pronounced.

With a small or distant light source, the rays of light have little or no overlap, giving the shadow a crisply defined hard edge. The darkest part of the shadow, known as the umbra, covers most of the area and the lighter, softer part of the shadow (known as the penumbra) is found only at the far fringe. The penumbra increases in area as it gets further away from the shadow-casting object.

However, with a large adjacent light source there is far more overlap of the light rays, which results in a shadow with a much softer edge. In this case, the umbra becomes much more prominent, as the edge is being filled by overlapping rays from the larger light, and it is the penumbra that is less prominent. The larger the light and the closer it is to the object, the softer the shadow becomes as more rays are able to overlap into the shadow area.

As the distance of projection increases, the shadows can become

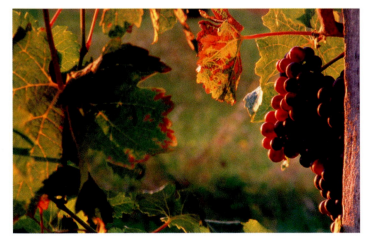

This image makes use of relatively hard light from a setting sun. Note the hard edges to the shadows, the sharp highlights and the clear demarcation where form turns from the lit to the shadowed side.

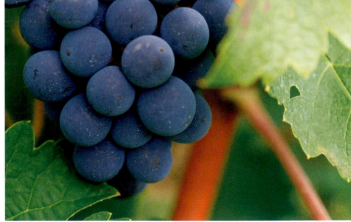

This image taken in overcast daylight has a very different character – there are no sharp highlights, shadows can be found only in the deepest recesses and the form turns very gradually from lit to shadowed.

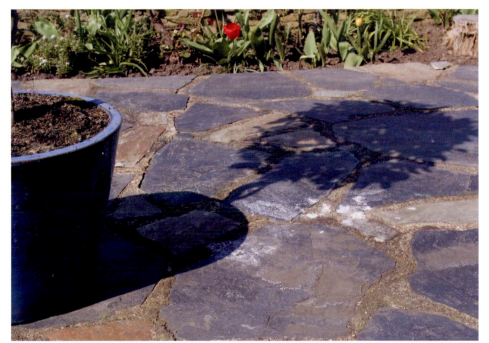

very soft indeed, even in harsh midday light. This softening is not a uniform blur, but is much closer in appearance to the optical blur produced by a lens, so the soft forms become rounded, resulting in spots of light and shadow.

During a partial eclipse of the sun, the rounded spots actually become crescents, as the pinhole projection of the sun changes shape.

ABOVE Note how this shadow is very crisp at the base of the pot, becoming softer as the shadow recedes from the plant.

BELOW In this image, captured during a partial eclipse of the sun, you can see how the gaps between the leaves become crescents instead of spots. They are, in fact, projections of the sun's image.

ABOVE In this shadow (top) the gaps between the leaves have become spots of light, with the small apertures acting as pinhole cameras and projecting an image of the sun onto the ground. Compare this with the shot taken from directly above, with the lens thrown out of focus (above), and note the very similar optical effect. This looks nothing like a uniform blur, but has a distinctive look of its own.

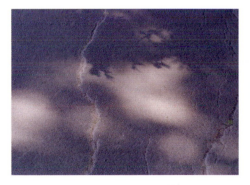

ABOVE Here the spots have softened even more, despite the midday sun, because the leaves are high above the ground, creating very soft spots. Note the contrast with the much sharper adjacent shadow.

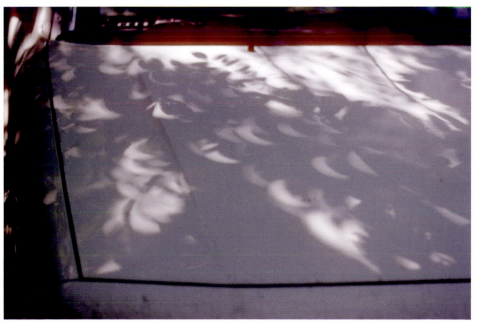

OVERCAST DAYLIGHT

Overcast sunlight is completely different in character from direct sunlight. All shadows will be very soft since the entire sky will be acting as one enormous light source. Shadows can be so soft as to be almost non-existent, except for dark areas beneath cars or trees.

The soft quality of overcast daylight is very underrated, although most studio photography goes to great lengths to reproduce this effect because the low contrast and soft shadowing is flattering. It is actually quite simple to simulate an expensive photographic studio by taking photographs on white backgrounds outdoors on overcast days.

It is worth bearing in mind that any light source, whether reflected, diffuse or direct, will cast a shadow. In the case of a fill light this shadow may well be overpowered by the main light, or be so diffuse as to be invisible. However, whenever multiple light sources, including light coming from reflective surfaces, are being considered (single light sources are very rare in everyday life), there will be multiple shadows of some sort – even if they are very hard to spot. In many artificially lit environments these will be quite obvious, since multiple lights are the norm in any large area lit by artificial light.

There are significant differences in the characteristics of shadows cast by adjacent or distant light sources, and these are worth examining. Our only source of natural light is the sun, and it is very far away, which means that the shadows it casts are parallel (or so close to it as to be identical), but other sources of light are much closer to us and the shadows they cast radiate out from the light.

TOP This image is typical of overcast diffuse shadows – there are some very soft shadows behind the leaves and underneath the window but the contrast is low. Lack of glare, bright highlights and dark shadows can also increase the saturation of colours.

ABOVE A typical interior lighting scheme where an array of spotlights is used to light a kitchen, resulting in multiple shadows being cast around every object, as well as multiple highlights on reflective surfaces.

In this extreme example of diffusion, the overcast light is further diffused by the mist, resulting in the almost complete absence of shadows, except in the densest vegetation.

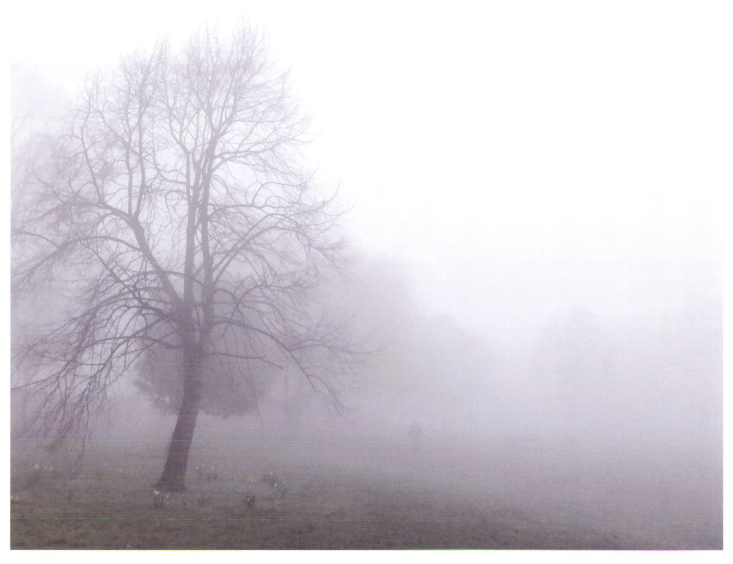

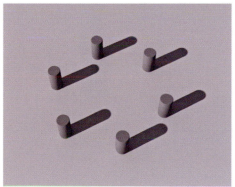

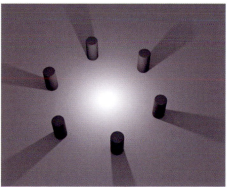

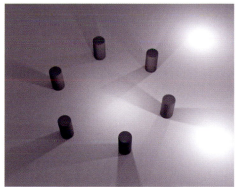

Shadows cast from a very distant light source such as the sun will be parallel to each other, and remain at the same relative thickness from the shadow-casting object.

In contrast to the previous example, shadows cast from a nearby light source, such as an artificial light, will radiate out from that source. Note how the width of the shadows themselves also increases as they radiate out from the light.

With multiple nearby light sources the shadows radiate out in multiple directions. Note the different amount of fill light received by each individual shadow, depending on its position in relation to all of the different lights.

Colour and shadows

Shadows are themselves illuminated by what is known as fill light, usually a secondary or reflected light source. In the vast majority of cases fill light will be coming from a soft and diffuse source, such as light reflected from a wall or the ground, or from skylight. This means that even in harsh sunlight, the shadow side of a form will be lit by diffuse light. Shadows are rarely black, but will generally contain some light and colour, which tends to be soft and muted.

In stronger light the contrast will tend to obscure the shadows, and in the case of photographs these can then become almost entirely black: our eyes are able to discern far greater levels of contrast than current photographic methods can reproduce. Even to the naked eye, though, the relative colours within a shadow will tend to be muted and homogenized, even if overall the shadow is deeply coloured, for example the blue shadows created by skylight.

TRANSPARENCY AND TRANSLUCENCY

Transparency and translucency can also have a major impact on shadow colour, in two different ways. First, the shadow-casting object may be transparent or translucent, and will cast a coloured shadow as a result. The most obvious example of this is glass, such as stained glass, casting what is essentially a projection of its image onto the walls or floor. Second, if the surface in shadow is translucent, light from within the surface can then emerge and affect the colour of the shadow. This is the phenomenon, known in CG terms as sub-surface scattering, and is commonly seen in human skin, marble, liquids such as milk, foliage, or any other substance through which light can travel. These materials should have enough saturation in their shadows to represent this extra light emerging from within the surface itself. The effect of this on human skin is covered in more detail later (see Chapter 11).

Within a shadow, colour relationships tend to be muted and colour is homogeneous. Here the shadow is a bright blue overall, overpowering the local colours of the surfaces. The contrast with the strong light nearby exaggerates this effect.

These two light sources are reasonably well balanced. In this case it is more helpful to think of two distinct light sources (the orange spotlight and the blue fill), rather than shadow and light. Both are strongly coloured but there is less tonal and colour variation overall in the blue shadowed side, owing to the lower contrast from the fill light.

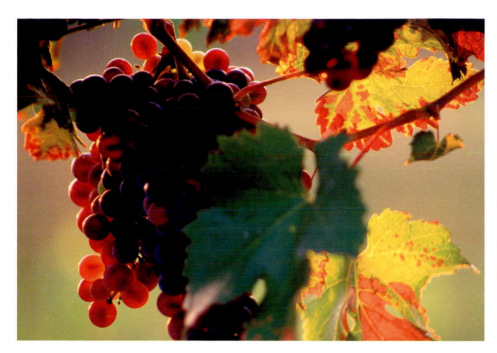

ABOVE The effect of translucency on these shadows is very clear indeed, since some of the grapes are in direct light and others are in diffuse fill light.

ABOVE RIGHT The coloured glass projects its colours as shadow on the window sill and the far wall.

RIGHT You can clearly see the blue tint in the shadow of the transparent blue glass here, broken up by the opaque blinds.

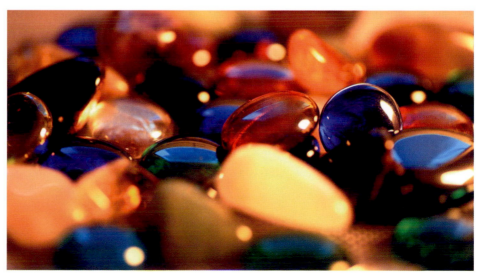

RIGHT It is possible to see the deep saturation in the shadowed parts of these beads, especially in the out-of-focus foreground. Even where the shadows are very dark they appear rich, with no dullness.

How we perceive colour

Benjamin Thompson, also known as Count Rumford, was the first person to notice that our perception of colour can be influenced by psychological factors. He noted that in strongly coloured lighting, shadows took on the complementary hue of the predominant colour, and only by observing the shadow in isolation from the primary light colour – by looking through a tube – did he realize that the effect was an optical illusion. Not all shadows will take on the complementary hue of the light source, but in very strongly coloured light this does take place.

There are also many physical factors affecting the colour of shadows. For example, the colour of the sky will have a much greater effect on shadows than will optical effects that may take place in our minds.

This subject is examined in greater detail in Chapter 10.

It is important to realize that there is often a lot of colour found in shadows, and just as our minds are capable of adding imaginary colours to shadows in strongly coloured light, they are also able to ignore them in other circumstances, and nothing will make an image look more dead than grey shadows. You should carefully consider the coloration in shadow areas, whether you want to reproduce nature or make a more psychological use of colour, because colourful shadows will lend a lot of life and realism to an image. Colour can be found in shadows for many reasons, be it strongly coloured light from the sky, an optical effect, or light scattered through skin or some other translucent material.

This lamp has a purple shade, which gives a very strong tint to its light: note the complementary green cast to the shadows, which is probably a very similar phenomenon to that observed by Count Rumford.

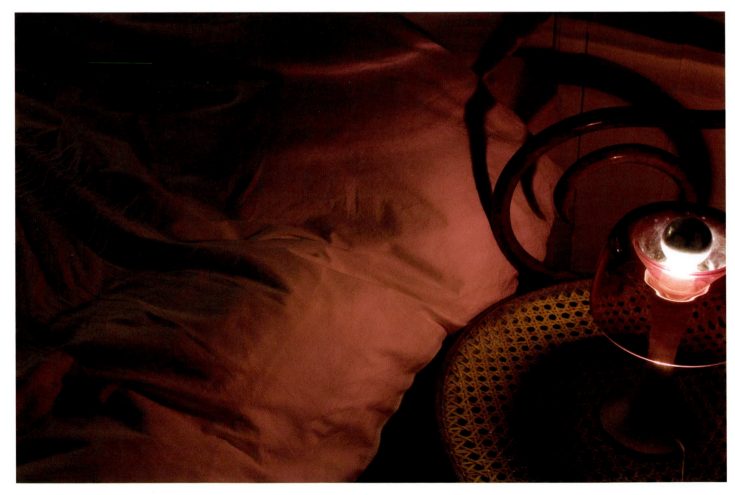

EXERCISE 5
Calculating cast shadow in perspective

Calculating how to cast shadows in perspective might seem like an extremely daunting task, but it's actually fairly simple.

This system is based on standard one-point perspective, with an added variable for the light source. When you have determined the position of your light source you can plot the shadows. This method applies only to distant light sources, such as the sun, since nearby light sources radiate from a single point and their shadows do not have a vanishing point on the horizon.

To understand how to calculate the position of a shadow look at this example:

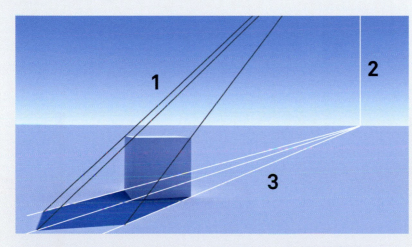

5.1 There is a distant light source, which is out of the picture frame, quite high in the sky. Determine the position of this light source and then plot lines coming from it onto the boundaries of the object (1). Then drop a vertical line from the light down onto the horizon (2). Finally, draw lines coming from that point on the horizon past the boundary points of the object (3), and note where they intersect with the first set of lines. The two sets of lines define the shadow, which you can now draw accurately. This is how to deal with a light source in front of the picture.

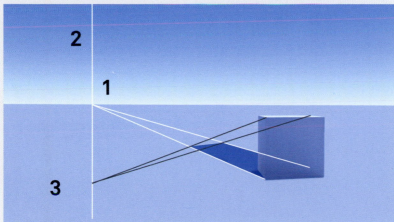

5.2 When the light is coming from behind, the method is slightly different. In this situation you determine the vanishing point of the shadows (1) by basing its direction on where the light is positioned behind the picture plane. Where the vanishing point meets the horizon, plot a vertical line downwards (2) and define a point that relates to the height of the light source in the sky (the lower this point is below the horizon, the higher the light is in the sky behind you). Then, from this point, draw some lines that connect back to the boundaries of the object (3), again noting where they intersect with the first set of lines. You have now plotted the shadows and will be able to draw them accurately.

6: HOW WE PERCEIVE SURFACES

Vision is the means through which we
process the electromagnetic waves that
hit the retina, constructing an image based
on the information received. When light is
reflected off a surface and then into the
eye it gives us information about the surface
of an object, and also about the volume
contained by that object. The volume is
not perceived directly, but is inferred
from the surface that envelops it.

The way we determine what a surface
is made from is mostly dependent on
its reflective properties. In this image
we can see that the figure is made
from wood, whereas the gramophone
horn in the background is made from
metal. We know this because of the
very different reflective properties of
the two materials.

Volume

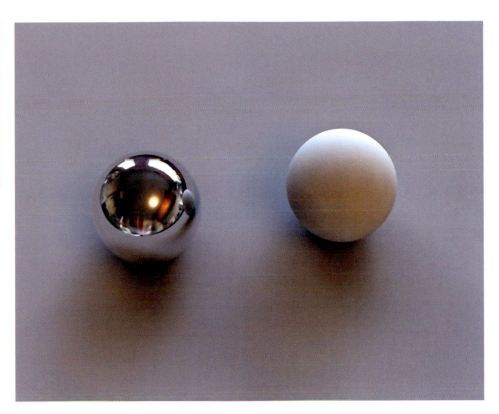

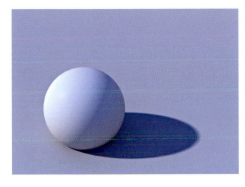

A basic volume can be described very simply. This image uses five shades of blue to describe a very simple box.

Despite the simplicity, we can read it as a volume in space with a distinct surface. The planes of the cube help to give a sense of depth and of space. Compare this with the next image, which is identical in all respects (same light source, same position), except that the cube has been replaced by a sphere.

Two things have happened: the rounded form has given us a much clearer indication of where exactly the light is coming from, since we can see the transition into shadow on the surface of the sphere, but, conversely, it is now much harder to interpret the sense of three-dimensional space because the form no longer has definite planes with which we can anchor it visually in the scene. It still looks solid, but it is a little more difficult to gauge in terms of its position in space.

Reflection

Diffuse reflection is what gives objects depth and dimension, and is the reflective component that lends colour to a surface. As light is reflected from a diffuse surface it is scattered along a very wide axis, and there is only the very vaguest sense of what is in fact being reflected – at best you can expect to see some lightening towards the light source, but there will be no detail.

Another common kind of reflection is called direct reflection, or specular reflection. This is the kind of reflection you get from mirrors, polished metals and water. In this case there is much less diffusion and therefore a much clearer image of what is being reflected. The local surface colour has far less influence on specular reflection (although the reflection itself can be coloured), and the form of the object is not defined by the lighting to the same extent.

Here you can compare the two kinds of reflection: diffuse reflection gives us information about the volume of the object, the matte sphere having a form shadow that helps define its volume. Specular reflection gives us information about the environment – the form of the shiny sphere is not conveyed by light and shade but by the distortion in the reflection. Note that in highly reflective surfaces there is no form shadow.

The specific characteristics of these two types of reflection is discussed in more detail in Chapters 7 and 8.

Because detail is far more concentrated in direct reflection, should you move around these two spheres you would find that the appearance of the matte sphere would change relatively little as your position changed, whereas the appearance of the shiny sphere would be in constant flux, since the angles and the reflection would change with your every move.

REACTION TO LIGHT

There are really only four fundamental properties that any surface will possess in terms of how it reacts to light: diffuse reflection, direct reflection, transparency/translucency and incandescence (emitting light). The two types of reflection are the most commonly encountered reactions, and in most natural materials, diffuse reflection is far more common than direct reflection. It is only with the advent of man-made materials that highly reflective surfaces have become common – polished metals are rarely found in nature – and liquids and waxes (such as those found on foliage) are among the only examples of natural surfaces with high reflectivity.

Surfaces define the volume of the objects they envelop, and light is what enables us to perceive surfaces. We see areas of light and shade, and these give us the information we need to picture the volume they describe.

Another very important element in this process is that of transitions, or edges. It is the edges between planes that help define the form of an object, whether those edges are sharp, as on a cube, or gradual, as on a sphere. Edges also define the boundaries between surfaces and between objects.

Traditionally artists have classified edges in the following manner: hard, firm, soft and lost, and these can be seen in the example on the right.

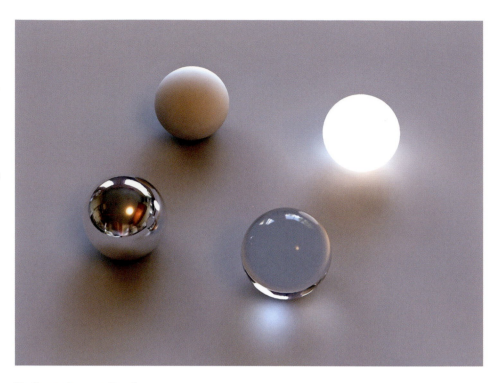

The four main properties of surfaces interacting with light, anti-clockwise from top: diffuse reflection, direct reflection, transparency and incandescence.

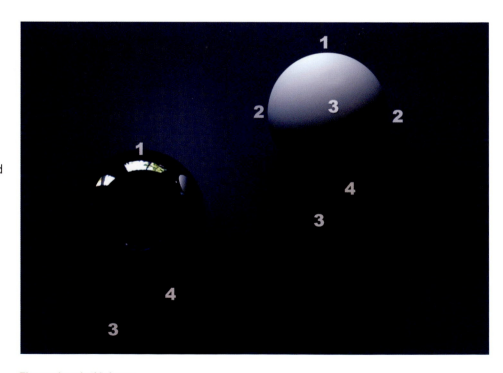

The numbers in this image correspond to the following: 1) hard edges, 2) firm edges, 3) soft edges, 4) lost edges.

Contrast

The concept of edges is closely linked to contrast – the harder the edge, the greater the contrast it represents. This is a very useful tool, which can be used to direct attention towards one part of an image while making other parts less important – in this sense it is more of a compositional tool than a result of observation. Our eyes are attracted to the areas of greatest contrast, which immediately become the focal point, whereas the areas with the softest or the lost transitions are of much lesser importance to the eye. With lost edges, even though some information appears to be missing, the viewer's eye can fill it in without damaging the readability of the image.

In terms of readability and visual harmony, an image will ideally have a mixture of hard and soft edges, otherwise there might be no sense of emphasis, making the image confusing to look at.

All that has been done in these three examples is to replace a shiny material with a matte one, which in turn has changed the character of the edges found on the surfaces from hard to soft. It is by mixing these qualities that contrast and interest are created.

TOP This image is distractingly full of hard edges and so is quite unappealing and confusing to look at.

MIDDLE By replacing the reflective background with a matte one, which allows for some soft shadows to contrast with the reflective metal, the image becomes easier on the eye. With the contrast provided by the soft shadows and the matte background, the spheres stand out more.

RIGHT Introducing another variable by making the majority of the spheres matte increases the contrast and provides a focal point.

The statue to the left of the fountain is defined only by thin slivers of light on one side, yet we are able to understand exactly what it is and can infer its form from the little information available.

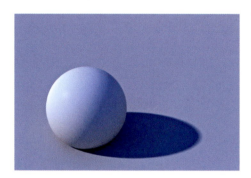

This is the original image, with no additional contrast added to the edges.

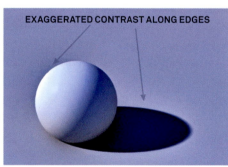

EXAGGERATED CONTRAST ALONG EDGES

Here a very obvious halo of extra contrast has been added along the edges: the darks are darker and the lights are lighter.

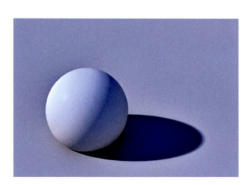

The final extra contrast has been toned down to be more subtle, but there is still a wide halo of increased contrast visible, and the image has more punch than the first example.

LOST EDGES

It is also possible to lose some edges completely without doing any harm to a composition. It can even help by merely suggesting areas without bogging them down in detail, therefore letting your composition breathe. If the statue in the photograph pn the left was as clearly defined as the rest of the image it might detract from the composition as it would no longer be offering contrast and variation. The lost edges aid the composition by suggesting that the area they inhabit is of less importance, thereby giving greater emphasis to the focal point of the image – the fountain.

MANIPULATING CONTRAST

At the other end of the spectrum are hard edges with high contrast. With these it is often worth exaggerating the contrast even further. Anyone familiar with Unsharp Mask in photo-editing software will know that this process involves artificially increasing the contrast between edges, although in that context it is usually done on a small enough scale for it not to be obvious. What you may not know is that your own eyes are also capable of playing a similar trick, and that your brain can create a halo of fake contrast around hard, high-contrast edges.

With this in mind you can manipulate the contrast of hard edges to enhance them further, thereby creating an image with more contrast and more impact. Look at the spheres on the left to see how this method can be used. The effect in the final example was achieved by using Unsharp Mask in Photoshop with a very wide radius, although you could just as easily do the same thing with paints and a paintbrush: simply paint in some added contrast around the edges to achieve a similar effect.

Surface qualities

When it comes to edges actually found on surfaces, rather than at their boundaries, one very important characteristic is that very few objects have perfectly sharp edges. This is a crucial detail when reproducing man-made objects, since their slightly rounded edges will often catch a highlight. Including this detail can add a valuable level of realism to an image.

On a more complex and representative real-world object the effect is perhaps more subtle but still important. Compare the images of the same key, below, in which the first has sharp edges and the second has bevelled edges – the second image is more believable and realistic.

Although the bevelled key is better, it still isn't a completely believable image. For absolute realism you will generally need to add some imperfections and wear to a surface, as shown in the third example; otherwise they can look too pristine to be real.

It's worth noting that in real-world objects almost any edge is rounded to some extent. Imperfections, however, are not so universal, and also come in a wide variety of forms, so you can't rely on a simple formula. However, imperfections add a layer of complexity that can benefit many surfaces.

Conveying form is the cornerstone of any kind of representational art, and form is defined as surfaces. Understanding the basic qualities of surfaces is the key to successfully suggesting three-dimensional forms, and the building blocks for achieving this are very simple: you start by conveying diffuse reflection, the main masses and shapes, then the direct reflection (if any), the highlights and subtleties of the form, and finish off by considering details and texture. This is the traditional work flow of the painter: block in the main masses, then gradually work down to the details. Although colour is significant, especially as a subjective tool for conveying mood, it is not an important component in conveying form, which is achieved through tone alone – in other words, through light and shade.

This cube has edges that are perfectly sharp, so it looks unconvincing.

Here the rounded edges catch the light, creating an instantly more realistic surface.

The sharp edges of the key give it an unrealistic appearance.

With a rounded edge to catch some highlights the image becomes much more believable.

Note how the imperfections catch the light by creating more planes for it to reflect off.

EXERCISE 6
Defining form

Light defines form. All modelling of form is done with light and shadow, and everything we know about the shape of any given surface is defined by the way light falls across it. The softness or hardness of the transitions from light into shadow directly reflect the characteristics of the surface: a hard transition depicts a hard edge; a soft transition describes a soft edge.

The only other important variables are the hardness or softness of the light source itself and the direction of the light. A hard light will define edges more strongly than a soft one, and light direction has a big impact on surface modelling. This exercise examines three simple objects in hard side lighting.

6.1

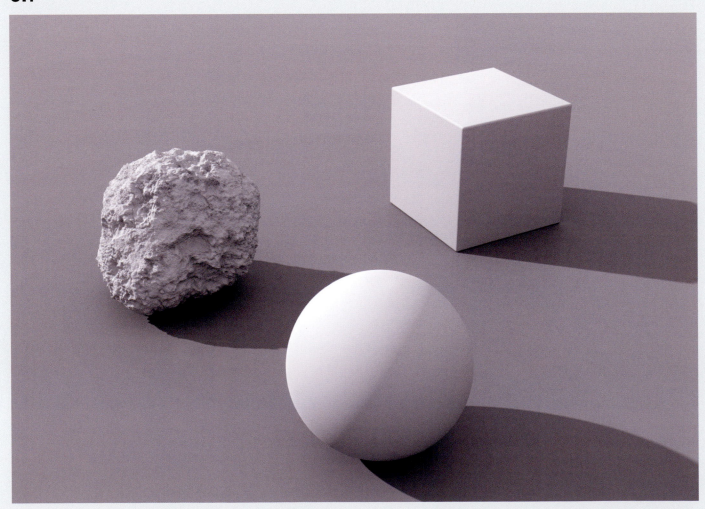

6.1 The cube is very simply defined by three shades of grey on its faces and a highlight running along the bevelled edge. The transitions are very hard, which tells us that the edges are hard. There is some modelling, especially in the shadow, where a little reflected light is bouncing up onto the cube.

The sphere is modelled by a softer transition from light into shadow, and this softness tells us that the surface is curved – the softer the transition, the greater the curve. The curvature also creates more of a gradient over the surfaces, with some soft transitions in both the shadow and the light areas. Note that the exact direction of the light is clearer when you are looking at the sphere.

The rock is based on a spherical form, but because of the heavy surface texture, the softness of the transitions is broken up, so there is a mixture of hard and soft edges all over its surface.

6.2 There is less contrast in softer light. The transition on the sphere is a little softer, and the rock also has less contrast. The overall form of the rock is harder to discern in softer light but the surface texture is still strongly visible. Finally, note how the highlights are much more muted, which is especially obvious on the sphere and on the bevelled edge of the cube.

6.2

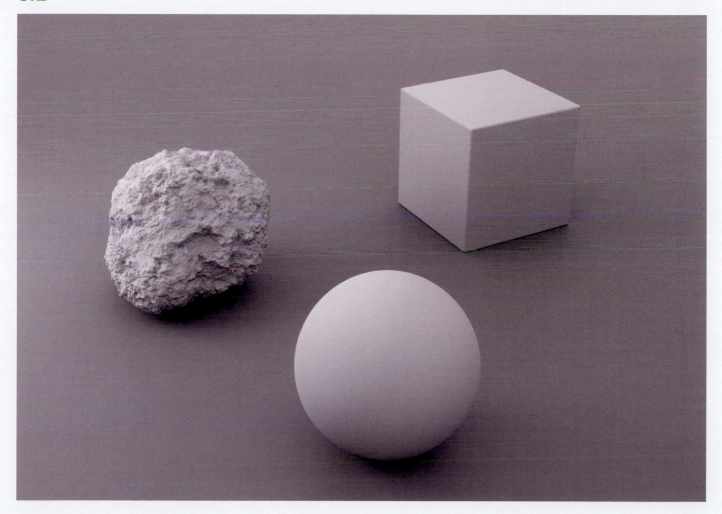

7: DIFFUSE REFLECTION

Diffuse reflection occurs when the light being reflected is heavily scattered (diffused) by the reflecting surface, and although this is usually attributed to the roughness of the surface in question it is actually a phenomenon that occurs at the atomic level. In fact, matte or diffuse surfaces can actually be quite smooth. What happens is a result of the interaction between light and matter.

Diffuse reflection is a property of non-metallic surfaces, substances that don't conduct electricity, known as dielectrics. Metals and non-metals have differences in their atomic structures that affect how they reflect light.

A rough white surface such as plain paper reflects light diffusely.

Colour

Photons are discrete electromagnetic particles of pure energy: they are not made of ordinary matter since they have no mass, unlike atoms. When photons come into contact with atoms they interact with the electrons that orbit the atoms, and either they are absorbed – in which case their energy is converted into kinetic energy and heat – or they are re-emitted and so create a reflection.

In the visible portion of the electro-magnetic spectrum, visible light, a black object will absorb all the photons that come into contact with it, and so get warmer in the process, whereas a white object will reflect all the photons and stay at a constant temperature. Surfaces that are coloured will absorb some photons

and reflect others, depending on their wavelength, so an object that we perceive as being red will absorb all other wavelengths, convert the energy into heat, and reflect only those photons that are within the red part of the spectrum.

On diffuse surfaces, when a photon is absorbed then re-emitted by an electron, its direction of travel will be altered: it will reflect away from the surface, but in a more or less random direction. This scatter-ing is what we know as diffuse reflection. The breaking up of the light's direction of travel means that any image is destroyed and matte surfaces have a smooth and even appearance because they mix all the light they receive into an even blend.

Diffuse reflection is what conveys texture and local colour in objects. Natural surfaces often exhibit a great deal of colour variation; uniform colour tends to be a feature of man-made materials.

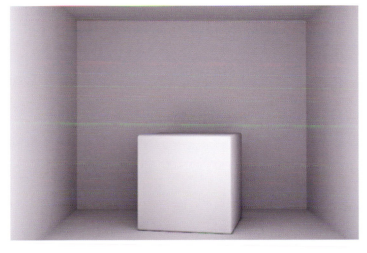

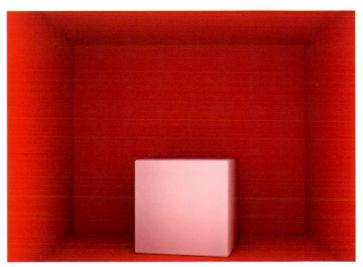

LEFT This cube is bright because bounced light reflecting off the walls adds to the overall illumination.

BELOW LEFT With exactly the same light source but in a dark environment, the same cube appears to be much less brightly lit.

BELOW In a coloured environment the effect of bounced light is even more obvious: it affects the colour of the cube.

Falloff

Another important component in the appearance of diffuse surfaces is light falloff. Light sources have a finite reach and as the light spreads further away it becomes more thinly spread and therefore dimmer. In the case of the sun this effect is not visible because of its immense size and its distance from us. However, with most light sources that are closer to us (including a window on an overcast day, for instance), the effect of falloff is significant. This last point is also worth noting because it describes a very significant difference between natural light and artificial light: falloff does not occur in sunlight, or in over-cast daylight outdoors. However, man-made light sources, as well as windows that let in diffuse natural light, are considerably smaller and nearer, so falloff will be a visible and significant property of such light, and this will give the light and the surfaces affected a very different look from that found in outdoor situations. Light follows what is known as the inverse-square law, which states that the brightness of the light is inversely proportional to the square of the distance from the light source.

Although diffuse surfaces are matte, they do react to the light sources to which they are exposed: a specular highlight or 'hot spot' often appears on the part of the surface nearest to the light, then a gradation into a darker tone will recede away from it. Falloff will accentuate this greatly, as in the first example above, but it can also occur in sunlight. Even in very uniform light it is good to have some gradation over a surface in order to bring some life and depth to the image. In the example, to the right, the top plane appears to recede as it gets darker, a device commonly used to convey depth.

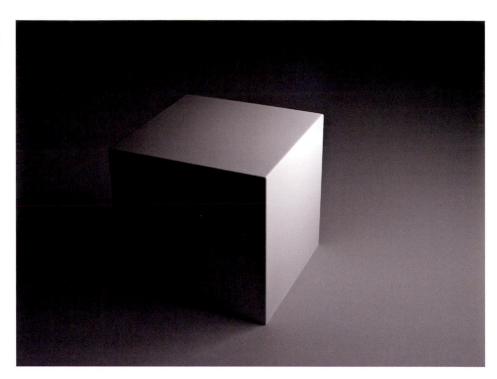

Here the light source is nearby, simulating a window on an overcast day. The falloff on the ground plane is sudden and clearly visible. There is a strong hot spot and gradation on the top of the box.

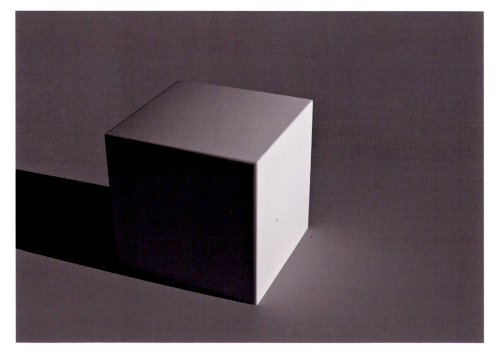

This light source is far away: there is little visible falloff on the ground plane. There is still some gradation on the top of the box, but it is far less pronounced.

Surface properties

Many of the properties pertaining to the interaction between light and surfaces, as described in Chapter 6, apply only to diffuse reflection: planes reacting to light, both cast and form shadows, secondary reflections from fill light, and the conveying of form are all properties that apply only to diffuse reflection – and the majority of surfaces will have a very strong diffuse component from which we can infer their form, colour and the material from which they are made.

Diffuse surfaces have a number of properties – local colour, surface texture and material type – that determine their appearance. The quality of the light hitting the surface will also have a big impact on the appearance of a diffuse surface: hard light will look different to soft light, and this will be most evident in the appearance of form and cast shadows, as described in Chapter 5.

Diffuse surfaces are heavily influenced by the lighting conditions around them: this may seem self-evident, but it does bear some examination. For example, look again at the boxes on page 73: the white box in a predominantly red environment is tinted red. Similarly, the same box in the very light environment appears much lighter than that in the dark one.

In hard light the form shadow of the spheres is sharply defined – the soft edge is due to the roundness of the spheres.

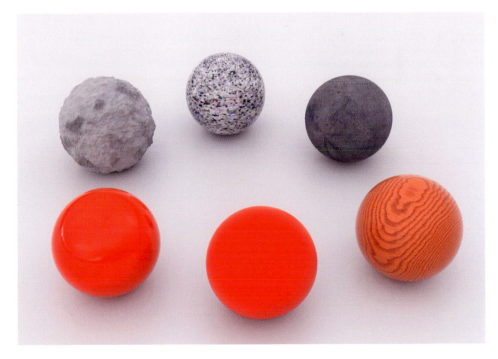

In soft lighting the form shadows become much softer, and there is much less modelling of the forms in light and shadow.

Shape and detail

It is mainly through diffuse reflection that we are able to discern the volume of an object. Direct reflection doesn't really convey volume information (as shown in Chapter 6), and form shadow is the main reason for that. Volumes are described by planes of light, or by smoothly rounded forms, and any volume – no matter how complex – can be described by these two basic means. All forms can be reduced and simplified, and even seemingly complex forms, such as trees, rocks or waves, can be described without getting bogged down in unnecessary detail.

The basic approach to describing complex and chaotic forms is to first describe the big shapes: for instance a tree might be broken down into a basic cylinder and a sphere. Once these are established, the quickest way to deal with the detail is to observe the nature of its overall shape and texture and then distil and interpret it into something simpler but visually similar. To try to reproduce every detail on a mountain face accurately is pointless, and most artists will convey an impression of it (to a greater or lesser extent, depending on the style required), an interpretation that leaves a lot of room for personal expression.

Another aspect of this process is the concept of detail frequency: the shape is broken down in stages from the big to the very small. Typically an artist will start by describing the big shapes, then medium frequency detail, and finish off with fine detail and texture, although this latter stage might often be applied only to certain parts of an image, such as the foreground or the main subject, leaving the other areas less detailed.

BELOW The highest level of detail here is reserved for the face; the background is painted loosely so the eye will focus on the subject. The background darkens as it recedes – a simple way to imply depth.

BELOW RIGHT On the cheeks the transition is gradual, describing a soft, rounded form. The smile lines have much sharper edges and here the transition from light to dark is sudden.

Transitions

Transitions in diffuse surfaces give us a great deal of information about their forms. With soft edges, the exact amount of softness in the transition describes to us the volume of the object: the more gradual and rounded the form, the softer the transition in its form shadow. It is very important to have a range of different edges to describe forms – a uniform generic soft edge will result in a fuzzy, indistinct image – and each edge should be used to describe a specific underlying volume. Light and shade describe the underlying forms, while tone is what helps the eye turn the corners of the form being seen.

The portrait below was taken in diffuse lighting: the roundness of the subject's face is described by the softness of the transitions between light and dark.

The quality of transitions can also give us important visual clues about the materials that objects are made of: hard edges imply hard materials, and an abundance of soft edges implies a softer material. This is readily seen in human subjects where soft tissues will have soft edges, while bony areas will feature harder transitions.

Wet surfaces

Rough, diffuse surfaces will tend to get darker when wet, partly because some light is lost to total internal reflection, and partly because specular highlights that would have been spread all over the surface owing to the high roughness are lost thanks to the water smoothing out the surface and creating brighter, more concentrated highlights instead.

Exactly the same thing happens when a glossy but clear coat of varnish is applied to wood: the varnish smooths the roughness of the wood, so it looks darker as a result but with brighter and sharper specular highlights. Specular surfaces, such as metals or mirrors, do not get significantly darker when they are wet since they tend to be smoother to start with – it is only diffuse surfaces, such as wood or stone, that do this.

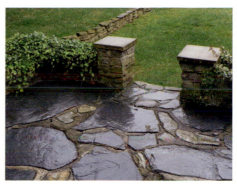

ABOVE Compare these two images of dry (left) and wet (right) stones. The water makes them darker and more reflective. You can see the strong darkening of the stone in the corners, and the reflection of the sky in the middle. The increased glossiness is creating a lot of contrast that wouldn't otherwise be present.

Texture

Fuzzy or velvety objects have a particular look to their surfaces, which is created by the structures within them. That fuzzy, velvety look is created by a network of small fibres all over the surface, which serve to diffuse the light even more than a standard diffuse material. These fibres catch the light in a more complex way than a smooth surface would, and this creates the characteristic sheen of these materials. The appearance is almost like a very soft gloss, but it is in fact mostly diffuse reflection, which is being broken up and softened by the material.

The suede jacket displays the characteristic sheen that is created by fuzzy materials. The various directions in which the fibres clump and point also make the surface more complicated than a simple diffuse light.

Light is being caught by some fibres, lightening the edges of the fabric.

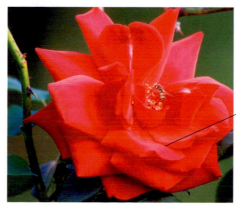

A close-up of this rose petal reveals a similar fibrous structure. Some subtle specular reflection is adding to the sheen. It is slightly glossier than the suede jacket.

EXERCISE 7 Detail and highlights

The detail included in this image might look daunting at first, and reproducing it exactly would be practically impossible. One way to deal with subjects like this is outlined here. This example was painted with the Brush tools in Photoshop, although it could also be achieved with any opaque media, digital or traditional.

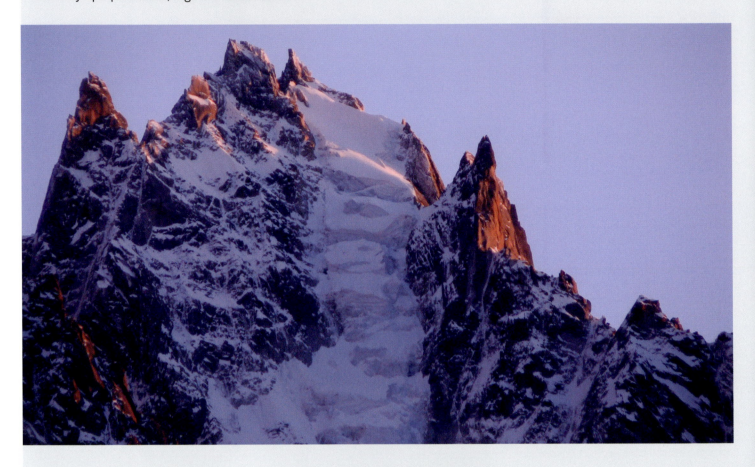

7.1 First block in the main shapes and colour, quickly and loosely, but accurately. Don't be a slave to the reference, but do try to observe your subject accurately.

7.2 You can do this next stage extremely loosely, scribbling very quickly to lay down some texture, most of which will be painted over later. This will help to create some visual chaos as a basis for the rest of the painting.

7.3 Add more scribbles, this time smaller and more controlled, and in a darker colour, to suggest some form to the rock. The painting style should still be very loose.

7.4 Using no more than three to four colours, add lots of small chaotic detail by continuing the scribbling method, but using small strokes and making sure there is a lot of variety to the shapes and patterns.

7.5 Use the reference to keep the feel of the original image, and to try to mimic the patterns present in the rock, but in a very loose and expressive way.

7.6 Finally, add the highlights to the edges of the rocks. You could now tighten up all the shapes laid down by this chaotic but effective process to create a highly rendered finished piece.

7.1

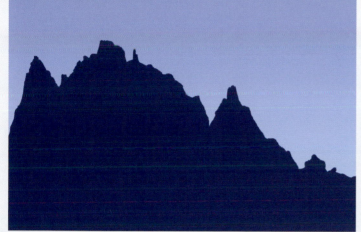

7.2

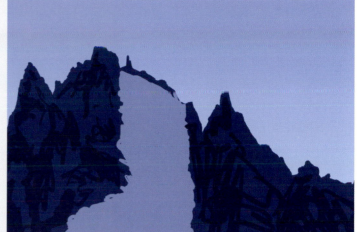

7.3

7.4

7.5

7.6

8: SPECULAR REFLECTION

Direct, or specular, reflection is the kind of reflection associated with mirrors: rays of light hitting the surface are reflected back at the same angle relative to the surface, thereby creating a recognizable image. Direct reflection is much stronger in metals. All surfaces exhibit some level of specular reflection, but metals have far more specular reflection than dielectrics.

In natural settings, highly glossy surfaces are rare, because most natural surfaces are rough – the big exception being water, of course.

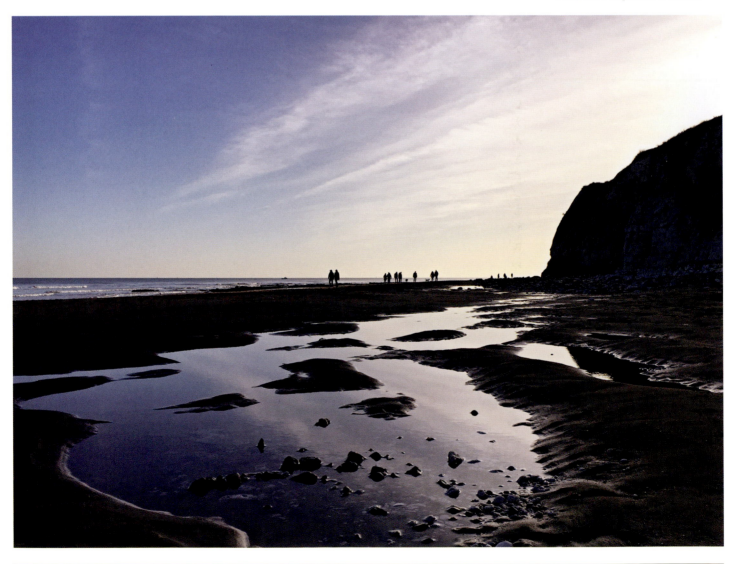

Surface qualities

Metals have a different atomic structure from non-metals: they have free electrons that can flow through them, which is why they are electrically conductive. These electrons also reflect light in a specular manner, which means that metals have far greater levels of specular reflection than dielectrics. For example, stainless steel will reflect roughly 60 per cent of the light that hits it directly, whereas glass and other non-metals typically only reflect 4 per cent of the light in a specular fashion (any other reflection from a dielectric will be diffuse reflection).

The amount of specular reflection for any given substance is determined by its index of refraction, but for non-metals this is usually between 3 per cent and 8 per cent (with 4 per cent being a good rule of thumb), while metals will range between 50 per cent for chrome, up to 90 per cent for pure aluminium or silver.

Although specular reflection is distinct from diffuse reflection, it's important to understand the role that surface roughness can play in diffusing specular reflection. A very rough metal, for example, will have no diffuse reflection at all, but the very strong specular reflection will be diffused by the rough surface. Conversely, a highly polished dielectric will still have a very strong diffuse component to its reflection. No amount of polishing a dinner plate will cause it to reflect like a metal, because only 4 per cent of its reflection is of the specular variety, the rest being diffuse reflection that remains diffuse no matter how smooth the surface. So while you can have a diffuse specular reflection (this being the result of a rough surface) you can never have a sharp diffuse reflection.

While metals are able to reflect only in a specular manner (they have no diffuse reflection at all), all opaque non-metals will combine diffuse reflection and a small amount of specular reflection. When viewed at a glancing angle the specular reflection will always increase in strength via the fresnel effect, which will be explained in greater detail later in this chapter. Smooth surfaces will have sharper specular reflections than rough surfaces, and smooth surfaces will always reflect bright light sources via their specular reflections. In non-metals specular reflection is never tinted, it is always neutral in colour (reflecting the colours of the scene); only metals have coloured specular reflections. Gold and copper have very strong tints, and metals such as nickel or titanium have more subtle, but still noticeable, tints.

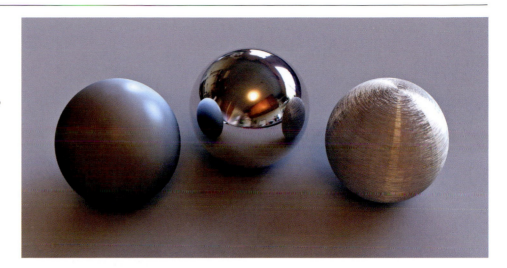

<u>TOP</u> If you look closely at the middle, most reflective ball you can clearly see the light sources illuminating the room. In the less reflective ball on the left it's clear that the highlights are being created by those same light sources. Now examine the more complicated ball on the right: it too is reflecting the same lights but because its surface has many grooves, the reflections are multiplied by each individual edge on the surface.

<u>ABOVE</u> Some typical variants of reflective materials, ranging from very hard and bright to softer and more blurred.

GLOSSY SURFACES

Glossy surfaces are smooth because smoothness is a requirement for sharp specular reflections – surface roughness will blur specular reflections and create a more matte appearance. On non-metals, only the brightest objects will be reflected, which is usually the light sources, as nothing else is bright enough to be visible. Looking at these two balls (right), it is clear that the reflections differ only in their strength and sharpness, so only the brightest objects, such as the lights, are visible, and that the relative roughness of the surface is causing the reflection to blur. Do not confuse this roughness with diffuse reflection, however – the scattering from diffuse reflection occurs at molecular level and is not caused by the roughness of the surface, but rather by the way in which the atoms in the material reflect light.

Contrast also plays an important part in our perception of reflections: glossy leaves on an overcast day will reflect the white sky, resulting in a wide white highlight on the leaves. However, on a sunny day, the sun will overpower the reflection of the sky, leaving a small bright and round highlight on the leaves, and the wide highlight from the blue sky will not be visible as it will be overwhelmed by the much brighter reflection from the sun. The reflection from the sky is still physically present, but the range of contrast between the two reflections will be so high that only the brighter one will be visible, since overall light levels will be much higher throughout the scene and the eye can handle only a finite amount of contrast.

Large light sources will have large specular reflections, whereas small light sources will have small reflections. This is clearly visible in the images of leaves in different lighting conditions in the photos on the right.

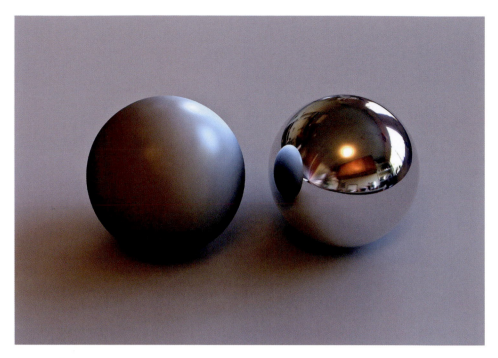

It is important to understand that the duller ball on the left is reflecting exactly the same things as the polished one, but the reflection is considerably weaker.

In this reflection, the sun, being very bright, simply overwhelms the more subtle sky reflection to the point where it is invisible – this is simply an issue of contrast.

Here, leaves on the same bush were photographed in the shade. Now that the sun is not in the reflection you can see that the blue sky forms a wide specular reflection over a large part of the surface of the leaves.

MAN-MADE SURFACES

Many man-made surfaces will have glossy specular reflections, often just enough to reflect the light sources. The quality of the reflection may be affected by the type of material on the surface: not all surfaces provide smooth and straightforward reflections. Sometimes specular reflections will be blurred, broken up, distorted or coloured.

UNEVEN SURFACES

Uneven surfaces will cause the specular reflection to be blurred: this is very common in a wide variety of materials, from lacquered wood to plastics and metals. In cases where the surface is extremely rough, the reflection will be broken up into lots of individual reflections (the surface of the sea, for instance). When this happens the reflection will not be able to contain any detail, but will consist of only the very brightest items, so that it looks as if lots of little suns or skies are being reflected in the broken surface.

The surface of fabric is also broken up, the individual threads creating lots of little highlights. Different fabrics will have different specular properties – some, such as silk, being very glossy; others, such as cotton, being more matte. But in each case the reflection will be blurred and spread by the structure of the surface.

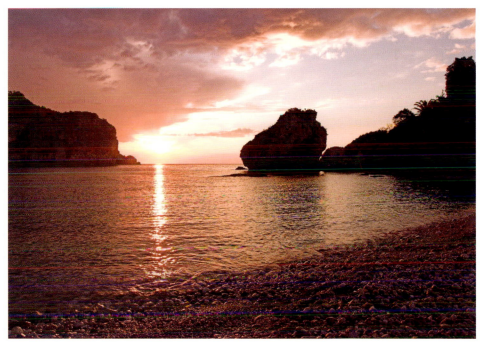

TOP This cast-iron fire hood has a rough and uneven surface, which leads to a very spread-out reflection as each little bump contributes a highlight to the overall reflection.

ABOVE The reflection of the rising sun is caught by the myriad peaks of the ripples in the sea, each one creating a separate reflection.

RIGHT The sheen on this fabric is spread out by the individual fibres, each contributing its own reflection, creating a range of broad highlights.

DISTORTIONS

Some surfaces, such as metal, have imperfections that are machined along a certain axis, taking the form of very fine grooves in the surface, which stretch and distort the reflections along their length like very small bevels. Reflections of this kind are called anisotropic reflections, and are associated with objects such as silk top hats, saucepans and machined metals.

By contrast, smooth surfaces will have clear and sharp reflections, the kind found on mirrors, chrome, glass and water. Even smooth reflections, however, can be distorted in other ways: depending on the shape of the object, the reflection may be distorted by concavity or convexity, as in fun-house mirrors or bathroom taps.

WEAR AND DAMAGE

Wear and damage can also affect the specular properties of a material, in some cases making it more reflective, in others less. When some surfaces are worn over time they become smoother: for example, stone steps that have been walked on over many years become polished by the wear and are more glossy as a result. Other surfaces that can become more reflective as a result of wear are painted metals – when the paint is worn or chipped off it exposes the more reflective metal beneath it. Of course, for many materials the opposite is true – wear or damage will make them less glossy: smooth surfaces can be chipped, scratched or blemished, and become duller as a result, or glossy paint or varnish can wear off or become damaged, exposing the duller material underneath.

This is an anisotropic reflection: the reflections are streaks running perpendicular to the machined grooves in the metal. Each groove is catching its own highlight, so instead of one continuous reflection there are many small ones.

In this close-up you can see the grooves and the way that the highlights run along them. Note also how the imperfections and wear affect the reflectivity of the surface.

Here a the layer of dirt is creating areas of lower specularity. Along the bevelled edges the reflection is being interrupted by the grime.

Damage has increased the reflectivity of this street post by revealing the shiny metal under the chipped paint.

Angles

Angles also play a very important role in direct reflection. The greater the angle relative to the surface normal, the stronger the reflection will be. You can observe this when walking in or near shallow water: when you are directly above the surface of the water it will be mostly transparent because of the lack of reflection; however, as you look further ahead it will be harder to see below the surface because, as your angle of view becomes less perpendicular, the water will appear to be more reflective.

This is often referred to as the 'fresnel effect', and is much more obvious in non-metallic surfaces since they have low levels of specular reflection when viewed straight on, which gradually increase as the angle of view becomes less perpendicular. At the maximum glancing angle, all smooth surfaces will reflect near 100 per cent in a specular fashion, even if they are not metallic. The fresnel effect is less obvious in metals since they have higher levels of specular reflection to begin with, but even so the amount of specular reflection will also increase all the way to 100 per cent on a smooth metal surface at the glancing angle.

Angles also determine exactly what is being reflected in a specular surface: the reflection will be at the same angle relative to the surface as the viewer. Another common example of this phenomenon is the reflection found at bevelled edges, which, being rounded, are able to catch light from a very wide range of angles and are therefore usually able to reflect some bright light source that exists in their environment.

Here you can see that the surface normal, in red, is perpendicular to the surface. Direct reflection will enter and exit at the same angle relative to the surface normal.

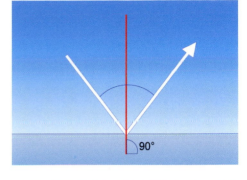

Compare these two reflective surfaces: a sphere and a flat mirror. The sphere can reflect the entire room around it, whereas the flat mirror can reflect only what is directly in front of it.

The reflections on this glass bowl are strongest on its sides, where the angle is more glancing. In the middle, where it is perpendicular to the surface, the reflection is weak and we are able to see through the glass more clearly.

This metallic surface is equally reflective all over, although the flat parts will reflect highlights only within a narrow range of angles, whereas the bevelled edges have a much greater range of angles to reflect and will therefore catch a bright highlight.

FLAT SURFACES

A flat reflective surface will be able to reflect only a narrow part of its environment, a property that is often used by photographers and filmmakers to ensure that their cameras are not caught in the reflections of flat mirrors. When photographing a reflective sphere it is impossible to omit the camera's reflection, so the only solutions are to use a very long lens from far away to make the reflected camera very small, or to retouch the image to remove it.

CURVED SURFACES

Curved surfaces also produce another characteristic: distorted reflections that follow the geometry of the surface. Reflections on a sphere will curve around the sphere; on a cone they will be pinched at the point; on a cylinder or tube they will be stretched along the length of the form.

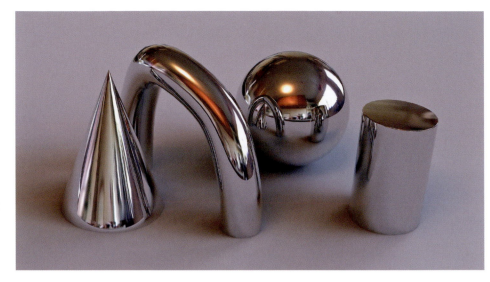

Note how the distortion of the reflection seems to follow the shape of the object.

Colour and tone

Surfaces that also have a strong diffuse component will have reflections that, to the human eye at least, are subtly affected by the colour and tone of the diffuse element in the surface. Dark surfaces will tend to emphasize highlights, whereas light surfaces will tend to emphasize the dark components of their reflections.

Black surfaces are often defined by their specular reflection – whereas a lighter object will have its planes defined by their diffuse reflections. This is far less obvious on a black object, since the diffuse reflection is necessarily very low. This means that any polished black object may have its surface planes described by the specular reflections on them.

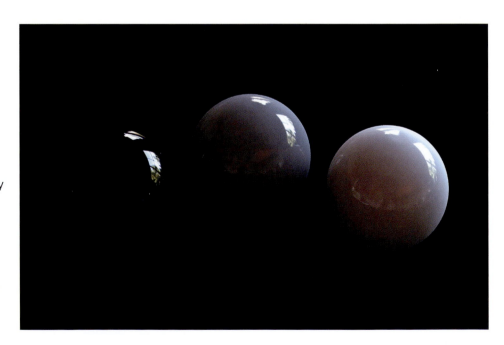

Although each sphere has the same amount of specular reflection, the black sphere appears to have more.

Specular reflections are not affected by shadows; these are a property that exists only in diffuse reflection, so if a surface is receiving a cast shadow, no matter how subtle, then it must have a diffuse component in its make-up. A true mirror cannot have a shadow cast upon it.

Reflection is a very important visual cue for surfaces that are wet. Many normally matte surfaces only become glossy when they are wet, so one of the simplest ways to give the impression that objects are wet is to increase their levels of glossiness. Combined with the associated darkening of the diffuse component (discussed in the Chapter 7, page 77) this is the main characteristic of wet surfaces.

Glossy specular reflection is a common feature of man-made materials. It is much rarer in natural materials. Specular reflection can tell us many things, from what materials the scene contains to the environment and the light sources affecting it. It is crucial to treat surfaces with different properties with varied and distinct types of specular reflection: are the reflections sharp, distorted, strong, faint, coloured, uniform, and so on? All these factors depend on the individual objects that are being depicted, and you should avoid the trap of treating specular reflections in a uniform and boring way.

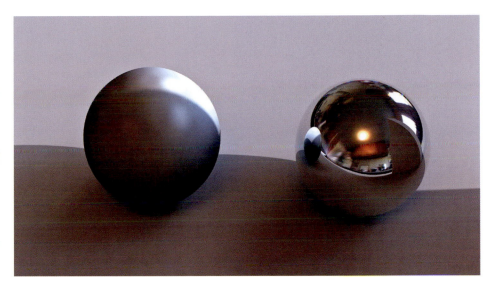

The shadow cast across this scene has no effect on the specular sphere, although you can clearly see the shadow-casting object in the reflection.

The specular reflection is unaffected by the shadow running across the box.

In non-metals, specular reflections are neutral in colour, but their relative weakness can give the appearance that they blend in with the colours of the underlying diffuse reflections.

The blue sky being reflected in this road and pavement indicates that they are wet after a passing shower of rain.

The transition between wet and dry can be seen on this stone. The wet area is very glossy whereas the dry area is not.

EXERCISE 8
Reflective surfaces in the real world

Dealing with reflective surfaces will be a necessity in almost any situation, since specularity is such an important feature of any wet or waxy natural material, and of many man-made materials too. Consider the following factors:

- What exactly is being reflected?
- What is the nature of the reflective surface, and why is it reflective?
- Are the reflections distorted, softened or broken up in any way?

The answer to the first question is obvious: the environment is what the reflection consists of, but the reflectivity of the material is also a factor. Is the whole environment being reflected or only its brightest parts? Many materials will only reflect light sources. There are so many types of material and variations in the way reflections can occur. Look at this painting of a tree frog:

Despite their differences, all areas do appear to be wet. This is the aim of the painting, since this is a fundamental property of the frog's surface characteristics. The rendering also reflects the qualities it is trying to describe: the legs are very smooth and blended, whereas the rougher body is rendered in a rougher way in order to create the necessary texture.

It's very important to plan how each surface is going to reflect light. In order to create convincing realism, the variation and the appropriate treatment of specular reflections should be given a lot of thought, since not all materials react to light in the same way. By observing the tremendous variation in materials around you, you will learn to bring some of that variation into your work and achieve a better understanding of light and surfaces.

8.1

8.2

8.1 Being wet, the frog has a range of specular reflections all over its body. However, since there is also a variation in texture over the frog's body the reflections are not all the same. On the legs, which are smooth, the reflection is pure and unbroken and the gradation of the blue sky is clearly reflected. This almost mirror-like reflection is created by water over a very smooth surface.

8.2 The body, however, does not have a smooth texture; it is lumpier and more porous, so the reflections are broken up more and are therefore blurred and less detailed. The subtle gradation of the sky is completely lost and the reflection is just a simple white from the brightest part of the sky, because instead of one large, smooth reflection there are now lots of smaller, broken-up reflections.

9: TRANSLUCENCY AND TRANSPARENCY

Some substances, instead of reflecting or absorbing light, let it pass through them, bending the light on the way in a process called refraction. Where the light is not scattered the surface is transparent, but where diffusion occurs to the light as it passes through the material the surface is translucent. In both cases there is an interaction between the substance through which the light is passing and the light itself.

The air bubbles trapped within this transparent glass are refracting the environment around them.

Reflection and refraction

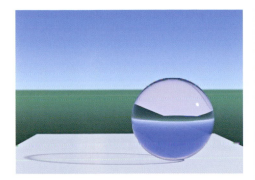

With refraction, the light is slowed down slightly, which causes the resulting bending of the rays. With diffusion the light is scattered, destroying any visible image. In their effects these two processes are somewhat similar to direct and diffuse reflection.

Apart from gases, all transparent materials (solids and liquids) are also partially reflective. This means that a percentage of the light hitting the surface is reflected, and the rest passes through. In the case of common glass, 4 per cent of the light striking the surface will be reflected, and the rest will be refracted. As discussed in Chapter 8, page 85, fresnel effects occur on transparent materials, causing reflection to increase as the angle of light moves further from the surface normal; thus the more off-centre from the transparent surface you are, the more reflective that surface becomes.

It is entirely because of reflection and refraction that transparent objects are visible at all, otherwise they would be like air, impossible to see. You should exploit these properties to make transparent objects more visible, since without careful management, their surfaces may be difficult to discern in certain environments.

Where the reflection is brightest it is much harder to see through the glass, but where the glass is reflecting the relatively dark bricks in the fireplace, the transparency is not obscured to the same extent. This effect is often seen in bodies of water or in windows – where the reflection is darker, the surface appears more transparent.

This very exaggerated example shows what can happen with a badly managed scene containing a transparent object. With too little contrast within the environment for the glass to reflect or refract, the globe doesn't stand out from the background.

With more contrast in the environment, the glass itself becomes more interesting: the darker areas above are refracted in the sides of the globe, and the bright light source is reflected in the front. The brighter ground is also refracted in the bottom edge. All of these details help to separate the glass from the background.

There are varying levels of transparency, and different qualities can be exhibited by different materials. In this set of spheres, right, the two spheres on the left are translucent and the two on the right are transparent. The translucency of those on the left is of different types: the one at the top is made of a diffusing substance that scatters light throughout its volume (hence the more opaque appearance), whereas the bottom one has a rough or frosted surface but a transparent core, and because of the texture the scattering occurs only on the surface – note how both reflections and refractions are equally blurred, since both the transparency and the reflections are being diffused by the rough surface of the globe. The red globe is transparent and coloured, so it absorbs most of the visible spectrum, letting only red wavelengths through. Finally, note how the refracted environment adds to the visibility of the two transparent spheres.

Transparency in natural materials is relatively rare, with water being the big exception. Otherwise, except for ice, crystals are the only relatively common naturally occurring transparent solids. Glass is very rare in nature. Translucency, however, is extremely common in many natural materials: foliage, wax, skin, stones such as marble, and liquids such as milk are a few of the many possible examples.

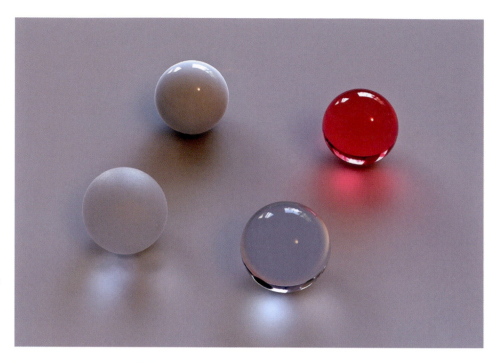

Note the differing effects of the light on these translucent (left) and transparent (right) spheres.

Here you can see water drops as they refract the incoming light. The view through the frosted window clearly shows a white sky with a darker ground, but the drops all show an inversion of this, with a dark top and a light base.

This glass has a strange red refraction along its edge, the cause of which must be a red object in the environment outside the frame of the image.

Pulling back reveals the red object that is refracted in the glass. Note that the dark edges on the glass are an identical phenomenon: the dark environment beyond the virtual studio set-up is being refracted and providing a useful dark contrast along the edges of the glass, which helps to separate it out from the light background.

In this example the lighting set-up has been reversed: the glass has been placed on a dark backdrop but a very bright environment beyond the image plane is being refracted in it.

Without the bright environment to provide refractions and reflections, the image of the glass is far less interesting, as well as being much more difficult to read.

The two key properties of transparent materials are refraction and, to a lesser extent, reflection. Refraction is caused by a slowing of the light as it interacts with the refracting material. The visible result of this is a bending of the light rays. Materials with a positive refractive index (which is most things) will bend light towards the surface normal, which means that curved surfaces can be used to concentrate light or to spread it out. This has real-world applications, including lenses that allow us to magnify things by spreading out the incoming light, with the larger spread resulting in a larger image. In any more or less spherical transparent object the image will be inverted because of the bending of light as it travels through the material – this can be seen in water drops, for instance.

Refraction also allows some of an object's environment to influence its appearance. Since any curved transparent object is acting as a lens of sorts, it refracts a much larger part of its environment than what is just directly nearby (because it is bending light). As shown earlier, this can be used to great effect to separate a transparent object from a background, using contrast.

Refraction is most apparent on the edges of the transparent surface. If the surface is curved that is where the greatest bending of light will occur, since the edges of the surface have the greatest curvature. On straight objects the edges mark the transitions, and different planes will show markedly different refraction effects. This also affects internal edges, so if there are bubbles within a liquid these will display refraction effects along their edges.

Note how the edges and sharp transitions show the greatest refraction effects. The cube and the cylinder have several high-contrast refractions along their edges.

You can see the effect of refraction at the edges of this glass desk. The green colour is a subtle tint in the glass that is visible when viewed through the much thicker distance that these edges sit along.

The edge of this candlestick is refracting the stained-glass window opposite. Note how the reflection of the window is on the left and the refraction on the right: reflection occurs on the surface directly opposite, whereas refraction goes through the object.

These raindrops are refracting the white overcast sky, making them stand out in high contrast against the green reflection on the surface of the water.

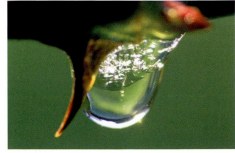

The bubbles inside this frozen droplet are refracting the sky at their boundary with the ice around them.

Dispersion

As light is refracted through transparent substances the different wavelengths are slowed down at different rates: the blue end of the spectrum is slowed down more and therefore blue light will bend at a greater angle than red light. This is what caused the colours present in white light to split into a spectrum in Newton's famous experiment with a prism. The effect can be commonly seen in everyday glass objects if you look for it, in the form of colourful halos in bright areas of the glass.

ABOVE LEFT If you look closely at the bubbles in this glass of water you can see the light being split into its component colours by the process of diffraction.

ABOVE The irregularities moulded into this pane of glass cause so many refractions that the glass is no longer clear enough to see through. Frosted glass uses refraction to obscure the view through it.

FAR LEFT The drops inside this glass ball are refracting the whole environment around them. Note that the bubbles are air, so it is actually the glass around them that is creating the refracted image.

ABOVE RIGHT A common illusion caused by refraction: the liquid seems to go to the very edge of the glass, so it looks as if the glass has no thickness.

RIGHT You can see the colourful effects of diffraction in this thick glass and also in the refracted caustic that is projected from it, which has a coloured fringe.

FAR RIGHT Another common refraction effect: the reflections tell us that the strongest light is coming from the right-hand side, but the glass base is brightest on the left, because the light is being refracted through the glass.

Caustics

Closely related to refraction is the phenomenon of caustics: a curved or somehow distorted surface will bend light and either concentrate or dissipate the beam, causing areas of modulating intensity with hot spots. Lenses can spread light out to magnify an image, and they can also concentrate light so that it creates a spot of intense brightness (think of magnifying glasses being used to start fires). These undulations in the intensity of the light can result in irregular shadows or hot spots being projected onto other nearby surfaces, a typical example being the patterns you see in shallow water at the beach. In the irregular surface created by waves in a body of water, light is concentrated and dispersed according to the concavity of the surface at each point of entry – this creates the distinctive patterns that are cast by water in the sea or in pools.

In surfaces that move, such as rippling water, the resulting caustic patterns will also move as the concavity of the surface changes and the light bends in different directions. The caustic effects caused by rippling water appear to ripple themselves.

Caustics can also be created through specular reflection, in much the same way as they are caused through transparency: if the reflecting surface is curved or irregular, the reflection can be concentrated to cause hot spots, which can be projected onto other surfaces.

Caustics are being cast as shadows by remnants of water at the bottom of a glass.

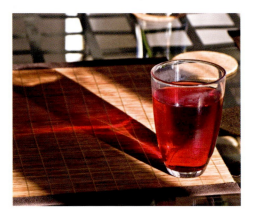

ABOVE LEFT A bright semicircular spot of red light is being projected by the liquid and the glass onto the table.

ABOVE The bright caustic reflections on this tree are projected by the specular reflections of the sun on the rippling water below it.

LEFT Even ripples in the water in a bathtub can project a distinct caustic pattern.

Shadows

As discussed in the previous chapters, shadows affect only diffuse reflection. Specular surfaces such as mirrors will not have shadows cast on them, and the same applies to highly transparent surfaces: no cast shadow will form across them, nor will any form shadow be visible.

Notice how in the photo below the transparent sphere on the right does not have a strong shadow cast across it, although the diffuse sphere has. Nor is there any form shadow to define its volume, which has to be guessed at from the reflections and refraction rather than from the shadows over it.

Translucent objects, of course, are different. They are likely to have a strong diffuse component and shadows may in fact be cast through the translucency. Again, there is a strong similarity in the way that specular

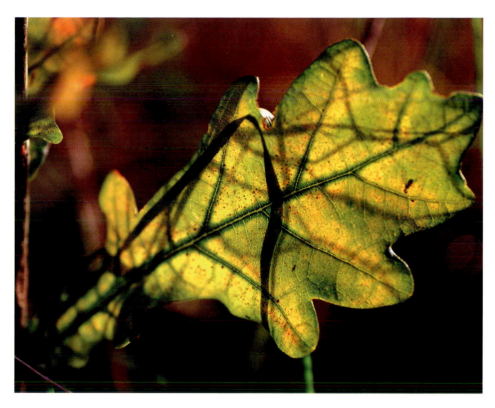

Shadows are being cast not only on, but through, this translucent leaf.

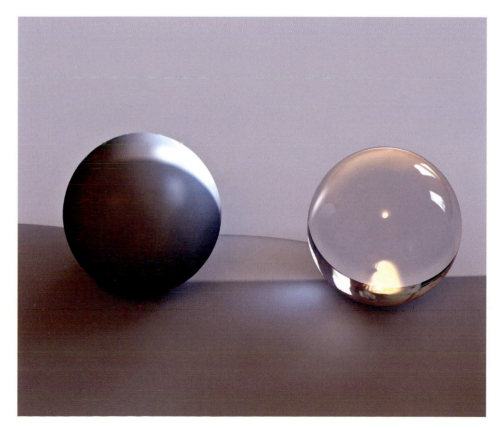

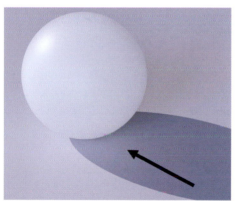

ABOVE A small amount of light is being transmitted through this translucent sphere and lightening the cast shadow.

LEFT See how the shadow cast by the sphere on the right is affected by its transparency – it is much fainter than other cast shadows.

reflection and transparency appear to be related, and diffuse reflection and translucency also behave similarly. Where diffusion occurs you will get shadows; where it doesn't there will be none.

Translucent objects can cast coloured shadows; since they are letting a portion of the spectrum pass through them, the light they let through is filtered by the object's colour and then casts a coloured shadow. Similarly, their form shadows are also affected by the light that they let through, and those form shadows are not only highly coloured but also less dense and dark than those found on opaque surfaces. This gives translucent objects a certain glow, since they rarely get extremely dark, even in shadow, and they also appear to be more colourful than opaque objects because their colours are intensified by the translucency. In certain situations, where contrast is high, translucent objects can appear to glow very strongly.

Translucency is very different in character from transparency. Translucent materials do not have clear refractions and they do not have caustics – this is because the light going through them is scattered, and these effects are destroyed by the diffusion.

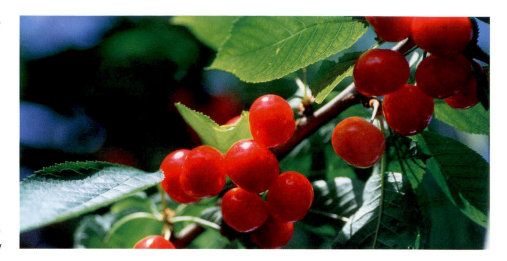

Note the softening of the form shadow on the cherries, and how light seems to show through many of the edges. The leaves are so translucent that there is no shadow on their underside.

ABOVE In these thicker translucent objects the form is flattened by the lack of a form shadow. Even the berries in shadow have a glow to them.

ABOVE RIGHT Translucency lends a glow to these leaves. The area of shadow really emphasizes the glow of the veins withinin the foreground leaf.

RIGHT To see the very obvious translucency in this marble statue, look at the collar of the coat: as the stone gets thinner, the shadow becomes lighter and much more saturated. Even the thicker parts of the stone have some translucency, and none of the shadow gets very dark when compared to the more opaque stone elsewhere in the image. There is more saturation in the shaded areas of the marble.

EXERCISE 9
Transparency

When painting or rendering transparent objects there are several things you should look out for.

The photo shown here has a few of the typical characteristics you would expect to find in any transparent surface, but they are complicated by the fact that there is water inside the glass, so the light interacts with two transparent materials.

9.1 Refractions are the most obvious property of transparent objects such as glass. The whole environment plays a part here but obviously the brightest parts are those most likely to be refracted. In this case the main light source is a window to the left, which is refracted all along the right-hand side of the vase.

9.2 Refraction is causing the liquid to appear to go right to the edge of the vase.

9.3 The window that is refracted on the right is being reflected on the left.

9.4 The stem of the rose appears to be detached from itself as it gets refracted through the water.

9.5 The table behind the vase is being refracted in miniature in the thicker part of the vase. The same thing is also happening in the water above, but not in the thin hollow part of the glass at the top. The thickness of the intervening material has a profound effect on how the refraction appears.

9.6 The edges of the glass are hard and very distinct: most of the refractive effects occur at the edges as they turn, and the reflections also increase at the edges due to the fresnel effect. The glass will appear more solid and opaque at the edges and more transparent in the middle.

10: COLOUR

In ordinary sunlight the white light emitted by the sun is actually a mixture of various wavelengths of light, which, seen together, are perceived as being white. It is important to understand that there is no single colour or light that can be defined as white – white light is always a mixture of other wavelengths (or colours, since it is wavelength that defines colour in light).

This computer render uses coloured lighting to create a moody and sinister atmosphere.

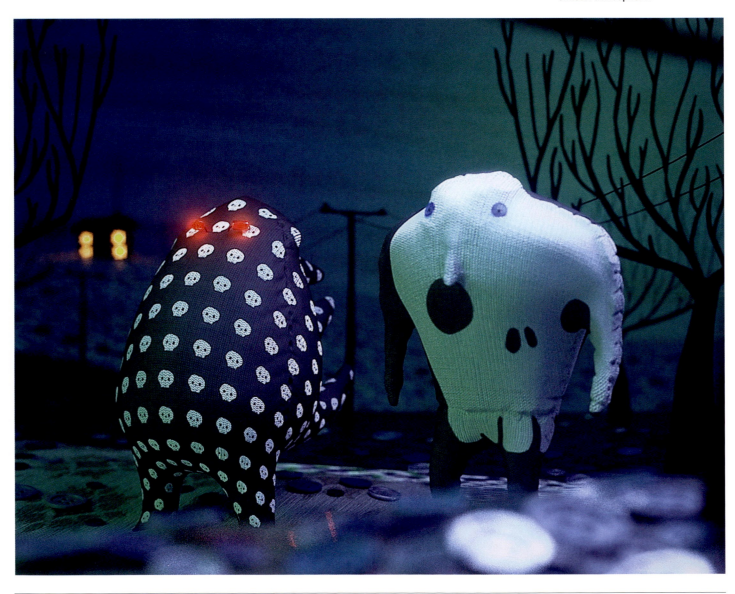

Colour spectrum

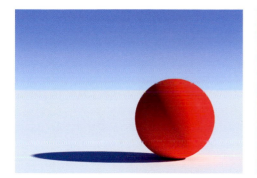

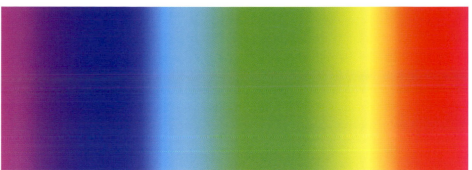

What happens when we see objects that reflect particular colours is a sort of filtering process whereby the surface absorbs some of the wavelengths and reflects others. Thus, a red object is in effect absorbing all of the wavelengths of light outside of a relatively narrow band in the red part of the spectrum.

The spectrum of white light emitted by the sun is a continuous band, which in the visible portion stretches from violet to red via all the other visible colours. The emphasis here is on the continuous nature of the colour spectrum – colours are not discrete steps with red followed by orange, but a gradual increase in wavelength that slowly morphs one colour into another.

Look at the diagrams on the right: these show the colour spectrum first as a band from violet to red, and then joined as a continuous colour wheel. However, the reality of coloured light is that the spectrum actually extends in both directions well beyond the visible range: beyond red lie infrared, microwaves and radio waves (with decreasing energy); whereas beyond violet are ultraviolet, X-rays and gamma rays (with increasing energy).

The range of wavelengths reflected back by any given surface is not fixed, but depends on the surface's absorption or reflection characteristics.

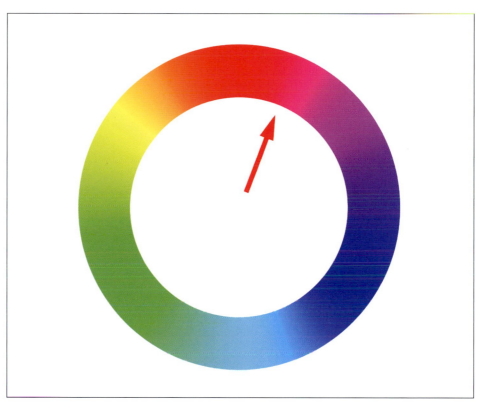

A paler-looking object will reflect a wider band of frequencies because its colour is closer to white, whereas an intensely colour-saturated object will reflect a much narrower band close to its component colour. Similarly, transparency is not a fixed property: glass, which is transparent in the visible spectrum, is opaque in ultraviolet, and many things that are opaque in visible light are completely transparent to X-rays.

TOP This continuous band can be wrapped around itself to form a wheel where the two opposite ends merge into each other seamlessly.

ABOVE The arrow marks the spot where the two ends of the daylight spectrum, red and violet, meet and merge in a colour wheel.

Properties of coloured light

Three properties are used to describe colour: hue, saturation and intensity, or lightness – these concepts will be familiar to anyone who has used a colour picker in a computer graphics program. Hue describes what we usually think of as colour, which is the actual value on the colour wheel; saturation describes the intensity of the colour, or how pure it is; and lightness describes the value, or how light or dark it is. In the diagram below, if Y is a given colour it can be defined by three criteria: A is its hue, as defined by its position in the spectrum, B is its saturation, as defined by the intensity or purity of the hue – the purer it is, the less white it contains (white being a mixture of other colours, as explained earlier) – and C is the intensity or value of the colour in terms of light, black being the absence of light.

If we put the full range of values for any particular hue on one scale, one thing immediately becomes clear: a colour has the greatest intensity in the middle of the scale, and as it gets darker or lighter the colour is gradually mixed with black or white and loses its purity. The consequence of this is that colour always appears more saturated when it is a mid-tone – shadows and highlights appear to have less saturation than mid-tones (even if the local colour is present it is not visible, since colour perception is weaker in shadows and highlights).

This theoretical model of colour created by light applies to visible light as seen by our eyes. Any physical means of depicting colour, such as a computer screen, for instance, will be limited by physical and technical constraints, and so will only ever be able to display a limited range of colours, known as its gamut.

Even human vision is limited in some ways, and many birds and insects are able to see much further into the ultraviolet than we can. When it comes to actual devices the limitations are much worse than our own vision: light-emitting devices such as computer screens or monitors have limited gamuts, and media that rely on reflected light (anything printed, for instance) are even more limited still, by quite a considerable margin.

Colour perception

Human colour perception is generally considered to be based on three primary colours: in the case of light (known as the additive colour model) these are red, green and blue. These three colours are combined by the eye and brain to create all of the colours we perceive, and this method is sensitive enough for us to be able to differentiate all of the colours in the visible spectrum.

Another very important point to understand is that the spectrum is a result of the white light emitted from the sun, and all the colours visible within it have to be contained within the light we perceive as white. The colours of the spectrum, when blended together, make white light. When this light is filtered by reflective surfaces of one colour or another they can only ever reflect what is already there – you can perceive a surface as being blue only because blue wavelengths exist within the white light; otherwise blue objects would appear to be black, since no light would reflect off them.

Light from the sun isn't the only light we see; we also use many artificial

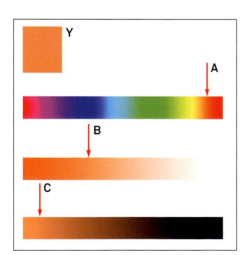

Here, the properties of the colour Y are demonstrated: A signifies its hue, B its saturation, and C its intensity.

This diagram shows all of the values for one hue (red) on a sliding scale.

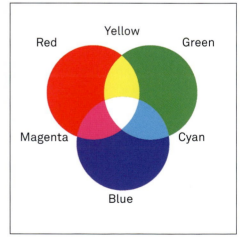

This is the additive colour model, showing how the primary colours of light combine to create the other colours and white.

light sources and they are all made up of different spectra, which can be quite different from daylight. This means that the colours visible under different kinds of lighting can vary considerably between one light source and another. However, the human visual system is very adaptable and our perception of colour is remarkably consistent, regardless of the nature of the light source to which we are being subjected.

OPTICAL ILLUSIONS

As discussed in the Chapter 1, colour perception is relative, and under differing lighting conditions we are still able to perceive colours as they would appear under daylight, so under very orange tungsten lighting a camera can render a very strong colour cast, whereas human vision adapts to perceive the light as being white. This highlights an extremely important fact: the perception of colour is highly subjective. We are not light meters and our perception of colour is always relative – colours are not assessed in isolation but in relation to the colours around them.

To demonstrate this point, look at the optical illusions here. In the first one, an illusion created by Edward H. Adelson, squares A and B are exactly the same shade of grey (cover the rest of the image to see this for yourself), but they appear to the eye to be radically different. In the second illusion, although both grey rectangles are absolutely identical, the one on the left appears to be slightly blue and the one on the right appears to be slightly orange. This is because the surrounding colour excites the eye into perceiving some of that colour's complementary colour around it. This is a similar phenomenon as that already discussed in Chapter 7, page 62, where complementary shades

appear in the shadows cast by very brightly coloured lights. Far from being a handicap, this filtering of colour perception helps us to focus on the important information for distinguishing forms rather than getting caught up in analysing individual colours.

Colour is never absolute. Perception is subjective and that therefore allows the artist a great deal of freedom to use colour for emotional or psychological purposes.

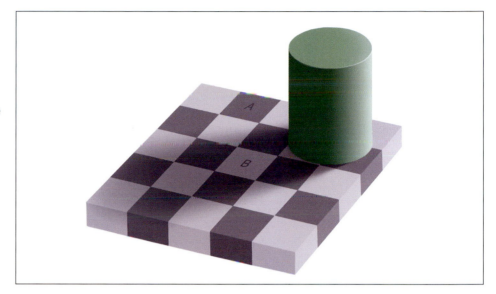

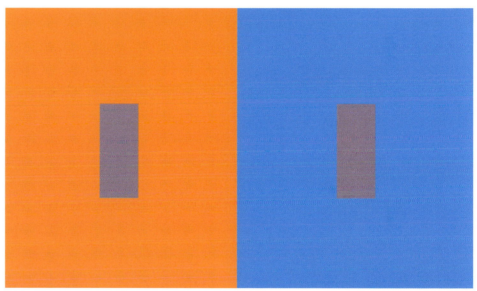

TOP Our eyes perceive square A to be in the light and B to be in the shade – our eyes enhance the sharp contrast between the various squares and ignore the soft contrast created by the actual shadow.

ABOVE Note how the grey rectangles in both cases appear to take on a complementary cast to the colour of their surroundings.

Manipulating hue

In terms of perception, hue is probably the least important attribute of colour. Value is the principal and most influential factor in defining forms; next comes saturation, which tells us about space and distance; then hue, which is very subjective. This means that it is possible to take enormous liberties with hue and still achieve a perfectly believable image.

Two factors will affect our perception of hue: first, the object's own hue, known as the local colour, and, second, the hue of the light source or sources. A strongly coloured light will have a significant impact on the perceived colour of the objects that it illuminates.

Under white light we have three balls coloured in the three primary colours of light: red, green and blue. The colours we see on the object are reflected back from the light source, so for each individual colour to be visible it must exist within the spectrum being emitted by the light.

Under a green light, red and blue wavelengths are no longer part of the spectrum, so there is nothing for the red and green balls to reflect and they appear to be black. In these conditions, both the white ground and green ball are reflecting solid green, but the brain isn't sure whether to interpret them as green or white.

If we then shine a yellow light on the scene, there is enough green and red present for the balls of those colours to appear in their proper

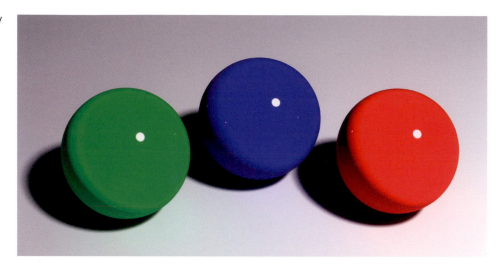

White light

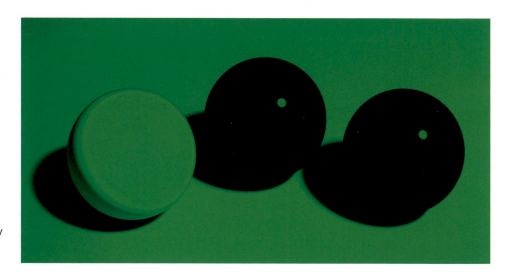

Green light

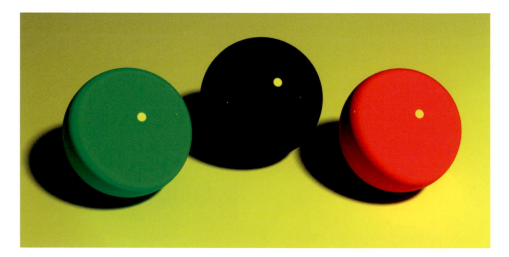

Yellow light

local colour. The ground is now differentiated from the objects since it reflects the combined colours in the light, whereas the balls reflect only their own colours. The blue ball, however, is still black, because there is no blue present in this light.

On the right we have a less extreme and more realistic situation: a very warm tungsten light. Notice how the blue is visible, but very under-saturated compared to the other two colours. Although blue wavelengths are present to some extent in the spectral make-up of this light, they are not present in the same quantity as green or red. Some commonly found real-world lights can be quite similar to this, and some street lights can have even narrower spectral ranges, showing no blue at all.

Below right, a second blue light is now acting as a fill to the left in addition to the main orange light. Note how the mixture of the two complementary colours in the lighting brings the ground back towards white. There is also now enough blue light in the scene to return the blue ball to full saturation. The shadows from the key light are now filled with blue, and the blue ball is visible (the orange light is hardly modelling the form, which is mostly lit from the blue light). Finally, a second set of shadows is being cast by the second light – these are filled with orange, except where the two sets of shadows overlap and go black.

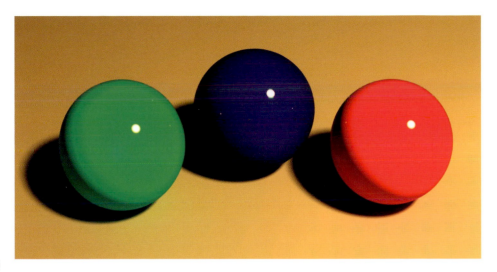

Warm tungsten light

Tungsten with blue fill light

Saturation

Most of the light that reaches our eyes is reflected light that has bounced once or several times between surfaces. Light that is reflected will be less intense and pure than light that has been directly emitted: the reflecting surface will act as a filter, removing both colour and intensity from the light as it reflects it. This means that in real-world situations intense colour saturation is quite rare, since strong pure colour is not often found in nature – in fact plants or animals that are highly colour-saturated are usually like that for the specific purpose of attracting attention, since they will stand out vividly from their less saturated surroundings. This applies to flowers that need to attract insects, or animals, such as poison-arrow frogs, who must let predators know they are dangerous.

Emitted light can be saturated, so skies can be very deep blues or oranges, depending on the time of day, since they are a light source; incandescent objects can also be very saturated since they are also directly emitting light.

In the image below, the sky and the sea have most of the saturated colour: the water, of course, is reflecting the sky once the angle of incidence is high enough, but the reflection is darker than the actual sky, and it is also less saturated. The colour of the rocks is also considerably less saturated than either the sky or the reflected sky. The foliage, however, is very interesting: it is translucent, so when daylight passes through it the resulting green is highly saturated because the leaves act as a light emitter. Note the huge difference in saturation between the foliage in light and the foliage in shadow.

In the same scene, but shot in the considerably more coloured light of dawn (top right), the sky loses saturation because there is very little blue light for the atmosphere to scatter, whereas the red in the rocks is heavily amplified by the colour of the light. The green is barely visible because there is so little green to reflect in the heavily coloured sunlight.

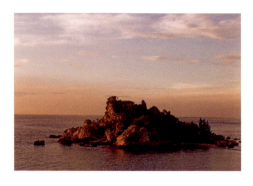

Even though this scene would appear at first glance to be heavily saturated, only certain colours, present in the light source, are reaching high saturation levels, while other colours are in fact being muted by these same factors.

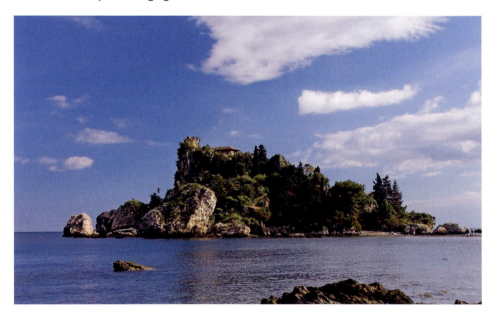

In this typical outdoor scene, the sky has most of the saturated colour. All of the reflected light on the trees and the rocks is at a much lower level of saturation.

Sky dark: hue 213; saturation 63; value 65

Sky light: hue 210; saturation 58; value 70

Water dark: hue 211; saturation 49; value 65

Water light: hue 212; saturation 42; value 65

Rocks light: hue 36; saturation 36; value 71

Rocks dark: hue 41; saturation 28; value 26

Foliage light: hue 68; saturation 65; value 50

Foliage dark: hue 57; saturation 31; value 23

This chart provides a breakdown of some of the prominent colours in the scene.

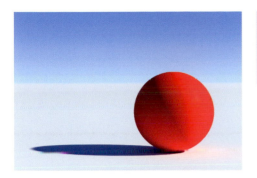

Outdoors, the form shadow on this red ball is less saturated than the light areas because of the blue fill light acting against the red local colour. The blue fill also makes the shadow appear darker by pushing the reflected colour towards black.

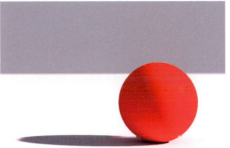

In a neutral environment the shadows have the same saturation as the lights, since the fill light is not coloured.

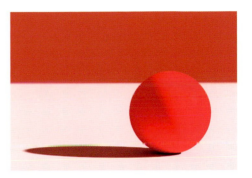

In a red environment the shadows are slightly more saturated than the lights because the red fill light is purer than the mixed white light shining on the right side.

SHADOW

The factors that determine how saturated shadows are depend simply on the light source. The illustrations of the spheres on this page demonstrate shadow in a range of conditions: in each of these examples the cast shadow on the ground reveals the colour of the fill light.

In sunny outdoor conditions any object that isn't predominately blue will have comparatively unsaturated shadows because the blue fill light will not contain much red or green light for the shadow areas to reflect.

In neutral lighting, such as we get in a photography studio, the shadows will have just as much saturation as the lit areas, because the white light will simply reflect the local colour, albeit at reduced intensity (or value). Shadow saturation is clearly highly dependent on the colour of the fill light. There are a couple of other factors to bear in mind, however: first, human visual perception is weaker at detecting colour when there is less light available, so shadows may well appear to be less saturated than light to the naked eye, and, second, other things can affect shadow colour and saturation – the translucency of skin, for example, can add a lot of red to the

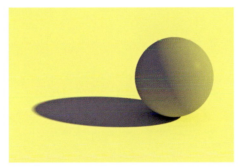

The shadow appears to be distinctly blue/purple, but in fact it is perfectly grey. Because there is so much yellow around the shadow, the eye mistakenly perceives the neutral area as a complementary colour.

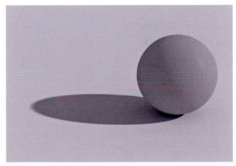

This image is similar to the previous one, except that all the yellow has been removed digitally – the other primaries were not present. Now you can see that the shadow is grey.

shadows on people. The main thing to remember, though, is to avoid creating shadows by just adding more black to the local colour. This can lead to dead and uninteresting shadows. Always consider using fill light, possible translucency and bounced light to create shadows that are full of life and interest.

Shadow colour is also affected by the illusion of colour contrast. This is the physical factor behind the often quoted artistic rule of warm light/cool shadows or vice versa. Many artists in fact enhance this illusion by exaggerating the colour component of any shadow areas.

Tonal values

Value is the final component of colour, and in terms of reading forms it is the most important. We can easily understand images where all colour information is removed, as long as the tonal values are still present – black and white photography is a testament to this. However, we find it considerably more difficult to make sense of images that have colour but no tone.

These images of the same train, right, demonstrate how it is possible to read the forms of the vehicle regardless of its saturation or hue, so long as the tonal values are present.

Below is a more extreme example: in this case the stage lighting turns the flesh tones blue, but we have no problem with the readability of the image and it doesn't seem to be particularly strange. In a different context it would pass without comment, despite the fact that the colours are far from what is considered normal.

This bright red train stands out from its surroundings. Without the bright colour the photo would probably lack interest.

When the colour is removed from the photograph, it becomes less interesting but still reads perfectly well.

If the tonal information is removed, leaving only the hue and saturation, the image becomes meaningless – it is very difficult to read the shapes, and almost all the spatial clues have been lost.

The local colour can be changed quite freely without really affecting the legibility of the image.

We are able to make sense of this image, despite the lurid, alien colours, because our eye is able to read and interpret the tonal values.

Colour temperature

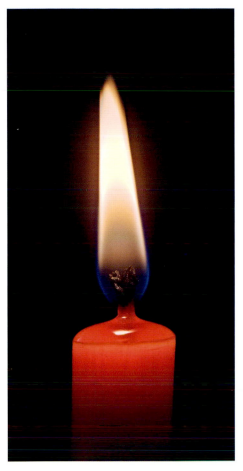

Here you can see the principle of physical colour temperature in action: the hottest part of the flame is the blue part at the base. As it rises it cools and turns yellow.

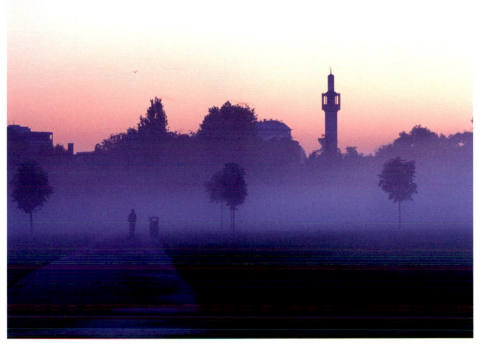

Here is a typical example of warm and cool together: the contrasting temperatures add visual interest to the image as well as creating an emotional response.

One concept favoured by artists is that of colour temperature, which is an idea that originally came from science. In scientific terms, colour temperature describes the radiation given out by a black object (known as a black body radiator) when it is heated up: initially the object will give out only infrared radiation, but when it becomes hot enough it will start to glow in the visible spectrum and give off red light, which gradually becomes white as the object gets hotter, eventually reaching blue when the object is heated to over 7,000 degrees Celsius.

In scientific terms colour temperature works in the opposite way to artistic or cultural ideas of colour and temperature: in electromagnetic terms red is a lower energy form of radiation than blue, so red is at the cooler end of the scale and blue signifies incandescence at much hotter temperatures. A blue flame burns hotter than an orange or red one.

The practical everyday application of colour temperature is in describing the colour of light sources. White incandescent bulbs glow at around 3,200k, daylight is rated at 5,600k. In practical artistic terms this is also a very useful concept when depicting incandescence: a glow should reflect the laws of physics to be convincing, and should start out with lower energy colours on the outside (such as red), with higher energy colours in the middle (such as white). Where light sources are concerned, this scale can only describe incandescent lights – fluorescent lights do not emit radiation from being heated up and can therefore emit colours outside the range of this scale (greens or violets, for instance).

| 1000k | 2000k | 3000k | 4000k | 5000k | 6000k | 7000k | 8000k | 9000k | 10000k |

In more traditional artistic terms, colour temperature is completely different; emotional or cultural references are used when discussing colour and temperature, so in this context red and orange are seen as warm, while blue and green are seen as cool. Although this is not a scientifically correct way of describing colour, it is of course very useful in directing the emotional response that you might wish to convey in an image, since we tend to associate red with warmth and blue with cold.

To convey an overall mood, a warm or cool theme can be used over a whole image, thereby creating a strong feeling of temperature. This is often seen in films where entire sequences may be shot with an overall cast to convey the requisite mood. This concept is known as working with a limited palette, where one family of colours is allowed to dominate an image in order to convey an emotional message. The easiest way to create a colour harmony or a limited palette is to use a strongly coloured light source that overpowers the local colours of objects.

Alternatively, there are some situations where local colour itself can be harmonious or in a limited palette: for example, the greens naturally occurring in a landscape, or well-matched clothing, or a carefully designed interior.

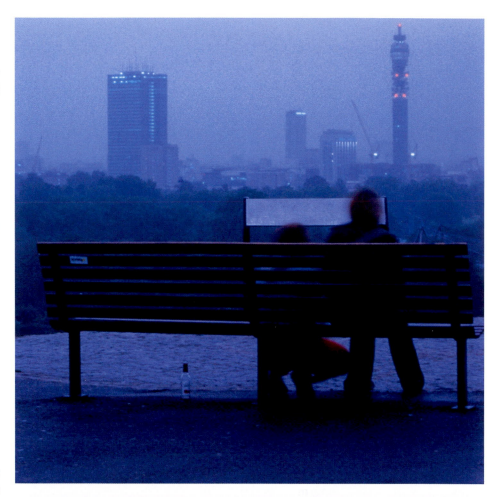

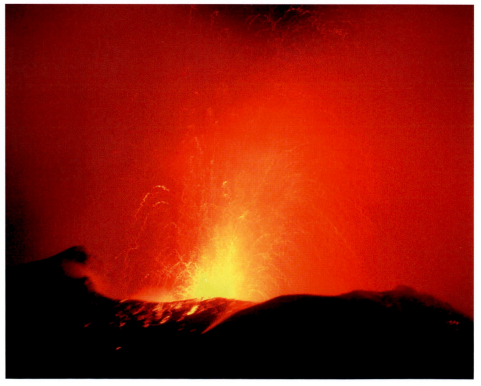

TOP The overall colour scheme of this image is cool blues, telling the story of a cold, wet evening to perfection. Compare this with the image below it.

RIGHT Here the complete predominance of warm colours helps to convey the idea of fire and heat made by the volcano of Stromboli. Note that the centre of the lava is physically hotter (more yellow, therefore higher energy) than the comparatively cooler red exterior.

Colour variation

Colour in the real world is subject to two main forms of modulation: hue variation and luminosity variation. Hue variation is the natural variation of the local colour of objects, and is caused by a number of factors, from natural hue variance to wear or exposure to the elements. Luminosity variation is caused by uneven lighting and is seen as gradations across surfaces. Cloudless skies, for example, will always have some form of gradation as the light gets weaker away from the sun.

Local colour variation is widespread in any natural material, be it foliage, skin or wood. It can also be found in man-made materials, although many of these have consistent colour by design, but age or wear may introduce variation into an object's local colour. There are many reasons for local colour variation, the most obvious being natural variation, although wear, textures, imperfections and reflections can also play a part.

Variation in local colour is more prominent in diffuse lighting and normal daylight. As soon as any kind of colour is introduced into the light this will have the effect of tinting all of the surfaces with the light's own colour, thereby playing down the effect of local colour. A strongly coloured light, such as the light of sunset, will unify an entire scene with its strong colour cast, and variations in colour (even between very different colours), will be harder to see. If you think of a typical sunset scene, everything in the light will be tinted red, and everything in the shade will be tinted blue by the skylight – the local colour is overpowered by the colour of the light sources.

Luminosity variation is often seen as a gradation, and is caused by any kind of variation in the strength of the light: this could be from falloff around a window or over the expanse of the sky, from forms slowly turning, from variation in the amount of reflected light hitting a surface or from subtle shadow.

TOP Here you can see the natural hue variation typically exhibited by foliage.

ABOVE This wall has many subtle as well as obvious variations in the local colour of its bricks. Some are the result of age; others are simply natural differences between the individual bricks.

TOP One place you will always see a gradation is across a clear area of sky. The sky is always brighter closer to the sun, while as it gets further away less light is being scattered by the atmosphere.

ABOVE There is a gradation at the top of this structure, caused by the turning of the form, and some modulation in the reflected sky. Within the car park there are multiple gradations caused by the falloff from the lights.

The falloff from the reflected sunlight causes a very strong gradation over this paving.

Here the thickness of the cloud varies and, as a result, so does the amount of light showing through the translucent vapour. Clouds show a complex combination of reflection and translucency, and, in the right lighting conditions, have gradations all over them.

All of the gradations on this swan wing are the result of subtle forms turning to shadow.

Here there are gradations within the reflections; the sky is being reflected in the metal and glass, and the gradations in the sky are also present in the reflections.

At the opposite end of the scale, in diffuse and even lighting there are very few gradations because the light is so uniform.

EXERCISE 10
Broken colour

One of the best ways of creating excitement in a painting is through the use of a varied mixture of colours, juxtaposing different colours to create variety and avoiding large areas of the same colour.

Nature is full of variety, and in order to convey this, many painters will exaggerate the variety of colours they see in order to create a heightened sense of reality. This leads to more interesting images that shimmer with life.

The following sketch was created in Photoshop to show how broken colour can be used to convey some of the variety found in nature. If we examine some areas in closer detail we can see exactly how colours are layered one over the other to create texture and life.

In nature, things are rarely of uniform colour and texture, and the way the light catches uneven surfaces gives a further appearance of broken colour.

10.1

10.1 In this portrait some very loose brushwork has been applied and dabs of colour have been used to create different layers. Colours can be mixed optically in this way, with dabs of lighter colour placed next to ones of darker colour and of varying hues, which then blend in the eye of the viewer to create a more complex whole.

10.2

10.2 This technique creates a loose and lively textural effect and can bring a lot of life and energy to a painting. The results look very loose in close-up but blend together when seen from a distance.

10.3

10.3 For the loose brush technique to be successful it's important to also apply some carefully rendered detail in appropriate areas, such as the eyes. If the eyes and the mouth are sharp and detailed, the rest of the face can be loosely rendered.

PART 2

PEOPLE AND ENVIRONMENTS

Building on the knowledge acquired in earlier chapters, this section shows how light affects the two most common subjects for any visual artist – people and environments. From how light can alter skin and hair, to how it changes foliage and water, any portrait or landscape is profoundly affected by light and the art of lighting.

11: LIGHT AND PEOPLE

People are usually the primary subject of representative art, so knowing how light interacts with flesh is extremely important to artists. Creating believable skin tones is a major preoccupation for many, and light is the key to understanding the appearance of skin. This chapter explores the relationship of light to skin and how to depict skin convincingly.

Light interacts with people in many ways. Rarely will you see a face that is not partly lit or in shadow, with highlights reflecting off the hair and eyes.

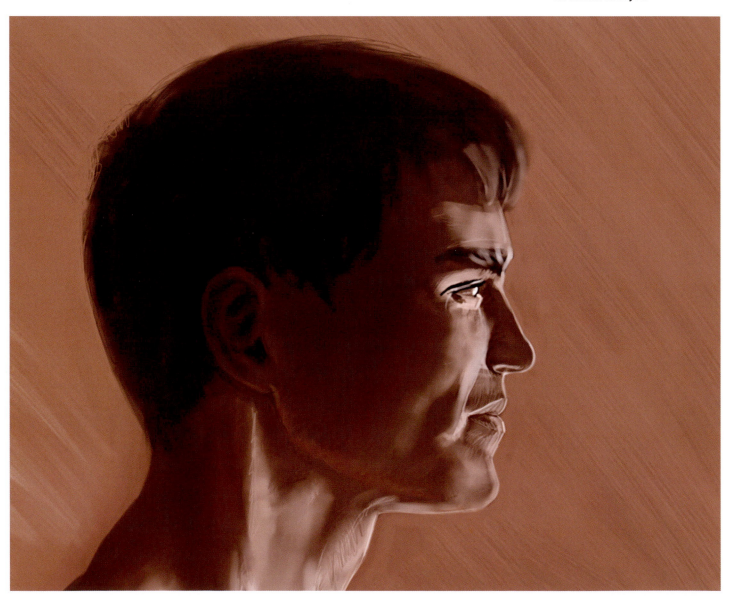

Skin

Human skin has a variety of properties that make up its appearance when interacting with light: it obviously has diffuse reflection, but it is also translucent and directly reflective and these qualities have a big influence on its character.

TRANSLUCENCY
Translucency is the feature that most obviously affects the appearance of skin. Skin is made up of several layers, and light is able to penetrate to some depth – so what you end up seeing is a mixture of light reflected from the surface and from beneath the surface. This has two major effects: first, the colour of skin is very much affected by the light scattering beneath the surface, especially in Caucasian people, where the reddish colour component comes from the blood beneath the surface of the skin; second, the shadows and transitions are somewhat softened by this scattered light re-emerging from below. In darker-skinned people the skin is more opaque, having more melanin, so translucency plays a smaller part in the overall appearance of their skin. The more pigment in the skin, the less light is able to scatter beneath the surface.

SURFACE VARIATION
The appearance of skin is also variable and is dependent upon its function and location on the body: the skin of the face is comparatively smooth and even, whereas the skin on the feet is tough and has a completely different texture. Skin is also subject to wear and weathering, as the existence of wrinkles obviously demonstrates. Different skin types among different races as well as among people of different ages also have a big influence on the overall look of an individual's skin.

The hand has a very interesting mix of skin types and makes a good

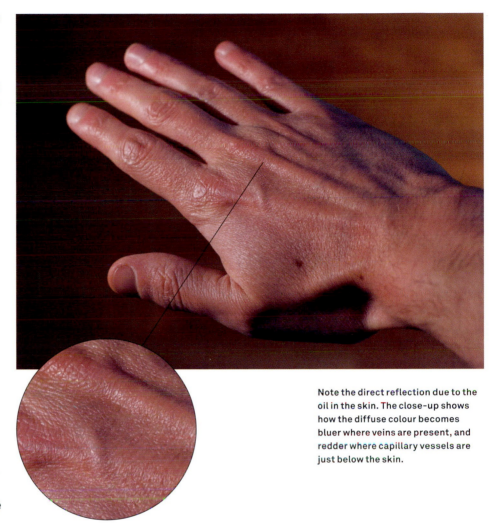

Note the direct reflection due to the oil in the skin. The close-up shows how the diffuse colour becomes bluer where veins are present, and redder where capillary vessels are just below the skin.

introduction to the subject. In hard lighting, as occurs in sunlight and in the photo above (taken with a flash gun), the first thing to note is that a lot of specular reflection is visible. We don't usually think of skin as being a highly reflective surface, but there is often a layer of oil present, which is responsible for this reflection. The close-up of the hand reveals that those parts of the skin facing the hard light are very shiny indeed, although the reflection is broken up by the complex texture on the surface.

The close-up also shows that the diffuse element of the skin is highly dependent on what lies directly below: where veins are present the diffuse

colour becomes much bluer, whereas the presence of capillary vessels, such as on the knuckles, creates a much redder colour. This shows that the light is reflecting from below the surface of the translucent top layers.

When no blood is present, such as when a tight fist is made and the knuckles flex, the skin becomes very yellow. We can assume that this is the actual colour of the skin and that the presence of blood below the surface is adding the red component that makes the overall colour pinkish. The sub-surface element plays a significant part in the overall appearance of skin; without this translucent effect skin would look very different.

HARD LIGHTING

When the hand is shot in harsher light, we see another effect created by the translucency. If you look at the terminator, the edge where the light meets the shadow, you can see a lot of red – in fact it is the most saturated area of the image. This is because the light is seeping through the skin. It is a less obvious manifestation of what you see when you shine a torch through your fingers, when the light comes through as a vivid red, having been scattered by blood vessels beneath the skin. The effect is particularly obvious on the raised tendon in the middle of the hand. The shadow areas where the direct light is able to scatter through are all warmed by the red light coming from beneath the skin, visible all around the shadow areas that are close to the light.

Taking a closer look at some of the shadow in the hand reveals a more subtle phenomenon. Even where the light is softer and subtler, the skin can still be very reflective, where the parts of the skin facing the secondary light source (an overcast sky through a window) are reflecting it.

There are many individual colours on the hand, from the red glow of scattered light on the edges of shadows and beneath the little finger, to the bluer light coming from the window, which becomes whiter where the window itself is being directly reflected. The ceiling is also reflecting light down onto the top part of the hand, providing a more neutral fill light that is visible on the wrist and forearm. Finally, the direct light along the far edge is white and very light pink and outlines the form and structure of the hand. Where the light is brightest it reveals the form very clearly. However, the skin in shadow also has a variation in colour where some patches take on different hues from surrounding areas.

Shot in hard light, a dark shadow falls across the hand, and quite a lot of red can be seen at the terminator.

Caucasian skin is naturally warm in tone, and even when in shadow the overwhelming influence of the light scattered by blood beneath the skin will add a red component to otherwise cool shadows. Blues turn to purple, and in direct light there is a real warmth to the colour of healthy skin. In the blurred version of the image you can also see the glow of the translucency around several areas of skin – it's what gives life to images of people. Be careful to avoid grey shadows and shadow edges when representing people – it's one of those subtle things that looks intrinsically wrong without really being obvious.

ABOVE LEFT If the photograph is overexposed you can see clearly that the effect of translucency is exaggerated. The red component takes over and the blue fill is much more difficult to discern.

ABOVE If the same picture is blurred, it is easier to see how colour is distributed across the hand without being distracted by texture.

SOFT LIGHTING

When the hand is photographed in soft light, the translucency affects the overall diffuse colour of the skin. The redness is now visible over the entire surface of the hand, and influences the colour everywhere. Even the shadows (which are far more neutral than in the previous examples) have a very big red component in their mix of colours.

Where the wrist and arm start, the skin becomes thicker, and the blood is therefore deeper below the surface and has less influence on the colour of the skin, which now becomes more yellow and truer to its real hue. (A suntan might cause a similar difference between hand and wrist colour.) Even in soft light, at least when it is directional, the specular reflection is very evident, and this helps to reveal the texture on the back of the hand.

If the photograph is blurred it is much easier to observe the diffuse colour of the skin, which ranges from very red and pink to more yellow. The fingernails have almost no impact on the colour of the hand – they are smoother and more evenly reflective than skin, but they seem to share the characteristic translucency and do not alter the underlying colours.

The skin on the palm of the hand is very different. Not only does it have a completely different texture – finer and more subtle – but it is also far less reflective, presumably because there is less oil on the surface. The reflection is smoothed because the texture is not breaking it up to the same extent. Areas that are sensitive, such as the pads at the fingertips, are also much redder, because there is more blood for the higher number of nerve endings present. The fingertips also have much softer direct reflections than anywhere else on the hand, possibly because any oil is removed by contact with other surfaces.

RIGHT & BELOW In soft light, redness can be seen over the whole surface of the hand, owing to the skin's translucency.

BELOW RIGHT The palm generally has less surface oil, and is less reflective. Also note how much redder the finger pads are.

Finally, with very soft frontal light you can see that the skin looks somewhat different again. There is no specular reflection, so the texture of the skin is much harder to discern. In this softer light, there is less subsurface scattering so the skin looks yellower, especially over the raised tendons where the blood is being pushed out. The shadows between the fingers are red. It is not advisable to use grey or black shadows on skin, since there is usually a strong colour component in the shadows of human flesh.

It's worth studying these images closely to see where you can find variations in colour, shininess and texture. Trying to understand what causes these variations will give a sound basis for recreating this surface in a convincing way.

In this very soft lighting, the skin looks slightly yellow.

Facial features

Faces are the most commonly portrayed human feature. People's faces, and their skin, come in many varieties of colour and texture, depending on age, race and sex. Skin can be pale, dark, blotchy, wrinkled, stubbly, porous, patchy, freckled, and so on. Some parts of the face are more reflective than others because of the presence of oil, some parts are bony and others are fleshy, and some parts have thinner skin or are more exposed to light (such as the ears, which are quite translucent).

Interesting textures and colour variations give life to the portrait on the right. It is important to treat different areas according to their qualities, so the bony ridge of the nose is defined by sharp edges, whereas the cheeks have more rounded and gradual ones. The shadow area is lit by cool light, and this has allowed for some interesting colours within the shaded side of the face.

By using a range of colours in the skin tones, even exaggerating or stylizing the colour variations, you can create more interesting renderings. There are variations in colour around the various features of a face – for instance, noses and cheeks are often redder than the rest of the face – but on a more detailed level there is also variation within the individual features, with the eye socket often darker and more red or purple than the bony ridge of the brow just above it. It is important to note these kinds of variation in colour, otherwise flesh tones can often end up looking dead and uninteresting.

TOP Here the skin hues range from a deep red to paler yellows, with some pinks and purples added into the highlights of the reflected fill light.

ABOVE In this sketch of an eye there is a lot of colour variation. It is far from being uniform in hue, with pinks below the eye and dark reds in the socket. Even the white of the eye isn't white but a meaty sort of pink.

This ear sketch also shows a lot of colour variation over the ear itself, from yellows to pinks. Note also how the areas of cartilage are shiner than the fleshy parts, such as the lobe.

Race and gender

Different skin colours react differently to light. Caucasian skin has the greatest colour variation because it contains less pigment than darker skin, so the blood below the surface exerts a much greater influence on the colour of the skin. Caucasian skin is more translucent, whereas darker skin is more opaque, so its colour is more consistent because the underlying tissues have less effect on it.

However, with darker shades of flesh, specularity becomes more pronounced, because darker skin creates greater contrast for the reflections to show up against (and darker surfaces always look shinier than lighter ones for this very reason).

Olive-toned skin also has less colour variation than pale skin, with more prominent highlights. Colour variation is less evident – Caucasian people often have more red around the nose, for instance, but darker skinned people usually don't; their skin colour is more uniform.

GENDER

Traditionally female heads are represented in soft light, and male ones in harder direct light – this is in order to complement the qualities that the artist or photographer wants to bring out in the subject. Direct light suits male faces because it emphasizes the strong planes of the jaw and cheekbones, whereas diffuse light is better at revealing the softer planes of the female face.

Diffuse light also reveals less texture, which again is desirable when lighting women in a flattering way. Men's faces can suit having their rugged texture revealed by harder lighting. There are no rules, of course; these are merely conventions, and you will find plenty of examples that fall outside of them.

Soft light is traditionally used on female subjects, as it flatters and softens the features and gives a glow to the skin.

There is still some colour variation around this face, but it is of a different nature to Caucasian skin.

Hair

The reflective properties of hair are distinctive and unique. Each strand of hair is very glossy and carries a very wide highlight along its length. Characteristically, strands of hair will clump into groups, so the highlights will also clump together to form large areas of unified highlights running across the hair. The tidier the hair, the smoother the highlights are likely to be – scruffy and layered hair will have broken highlights, tending to look duller as a result.

The best way to deal with hair is to approach it initially as a unified whole, looking at the main masses and clumps that are grouped together and observing how the highlights run over them. The highlights dominate the colouring of the hair, and create the greatest contrast and colour change. Even if there is colour variation in the diffuse component of the hair it is generally secondary in importance to the highlights.

Here the groups of highlights clump together in the strands of hair, and they provide all the contrast and colour change.

If the image is blurred it is easier to see how the highlights are grouped without being distracted by the finer details.

Here you can see the wide highlights on the hair, following the round form of the head.

When the image is blurred it's even easier to see how the highlights are unified and work as a group. There is much more colour variation in this hair than in the previous example, as well as a greater range of highlights over the length of the hair.

EXERCISE 11
Lighting the basic head

11.1

The simplest approach to lighting the human head is to break it down into its most basic planes. You can add more complexity later, but in most cases it is best to begin tackling any problem by taking it down to its simplest components to establish a starting point.

11.1 The actual form of the head is very simple. All of the minor details are omitted here, allowing you to tackle the problem of lighting from a very simple starting point.

11.2

11.2 When you have decided on the light direction and quality, according to the needs of your image, you can build on the basic form and add details such as jowls, cheek hollows and wrinkles.

11.3

11.3 Begin adding more complex and realistic bone structure only when you have figured out your lighting on the basic template. Without a proper foundation, the more subtle work that comes later will not be successful.

12: LIGHT IN THE ENVIRONMENT

Light is what defines the look of an environment. It affects every aspect of it and gives it many of its qualities and much of its visual appeal. Different lighting conditions will have a profound effect on the appearance of an environment, so an understanding of how light affects environments, both indoors and outdoors, is essential to their realistic depiction. In outdoor situations there are two main kinds of light: that which comes direct from the sun, or some kind of diffuse skylight, either cast from an overcast sky, or from skylight in the shade or after sunset.

With the sun behind cloud, the landscape is lit only by the light from the sky.

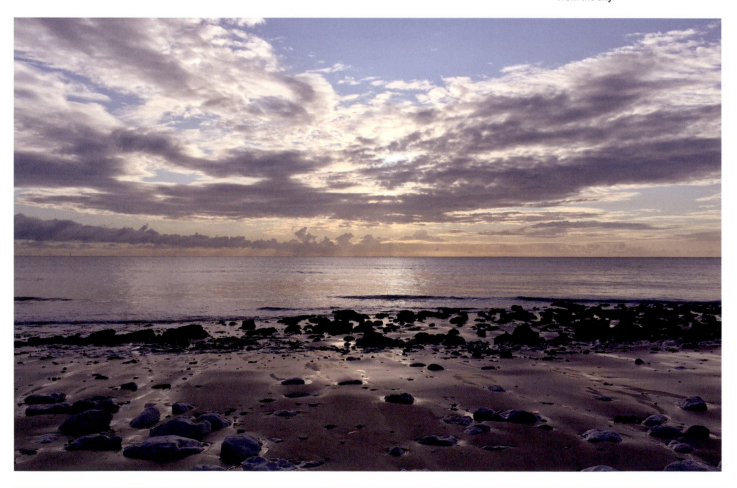

Skylight

Outdoors the sky has a very significant impact on the quality of light. Not only does the weather play a large part in determining that quality, but there is always some form of skylight cast outdoors – and in many cases the sky is the main source of light, such as when the sun is behind cloud. This means that the sky is the main factor determining the appearance of outdoor light, and is the first element to take into consideration when depicting an outside scene. Skies come in many guises, although the lighting conditions are fairly limited (refer to Chapter 3 for more details). Once you have decided on fundamentals such as the time of day, the kind of weather and corresponding light, you will want to think about a sky that will fit these criteria. Skies are very beautiful, with an attractive luminosity that, coupled with the varying quality of sunlight and the translucency of clouds, creates a huge variety of possibilities for the artist.

Skies, like landscapes, have several layers of interest and are subject to perspective. We think of landscapes having foreground, middle ground and background, and in the same way skies will have layers of cloud and atmosphere, ranging from low-lying cumulus clouds to very high stratus clouds. Depending on the position of the sun, these can have dramatically different lighting.

In the landscape photograph on the opposite page you can see layers of clouds in the sky – some higher and some lower. There is also a visible colour shift in the sky from blue overhead to yellow near the horizon, and these colours are then reflected in the water and on the shore. And because the sun is obscured by the clouds, the colours in the sky have a profound impact on the overall scene, since the sky is the sole source of light. Note how the clouds recede in perspective: the distant clouds are noticeably smaller than those in the foreground. The back-lit clouds have strong form shadows, but the contrast is much weaker near the horizon because of the effect of atmospheric perspective. All of this contributes to a sense of depth and atmosphere.

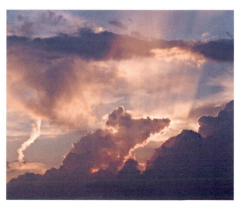

These examples show some of the range that skies can have, and the different lighting conditions, colours and moods associated with them.

Haze, fog and mist

Outdoors, atmospheric perspective will be significant. It comes in different guises, depending on the amount of water and other particulate matter in the air, so on a very dry, clear day it will be less significant than on a hazy, murky day. Pollution is also a key contributing factor, so most big cities will always have some kind of atmospheric haze.

The quality and colour of the haze is variable, but is generally based on the sky colour, so a blue sky often yields a bluish haze, a sunset sky might have an orange or pink haze, and an overcast sky would have a grey or white one – however, there are exceptions and it is quite possible to get a white haze in a blue sky.

Distance can also cause the haze to take on a yellow tinge, owing to the blue being scattered by the intervening atmosphere, even in the middle of the day. Another atmospheric effect occurs where light is visible because of the presence of particles (especially water) in the atmosphere. This is what causes sun rays to be visible in certain conditions. Even if the haze is too fine to be clearly visible, it can be lit up with strong light from the sun shining through it. In denser concentrations these water particles can form a mist or fog, which will have a very strong diffusing effect on light and create even and directionless lighting. The denser the concentration of particles, the more they will affect the visibility through the atmosphere, initially by reducing contrast and pushing local colours towards the colour of the atmosphere, and eventually rendering objects completely invisible at a certain distance. In clear skies visibility can extend to many miles, but in hazier skies it will be reduced, and in fog it will be limited to a very short distance.

Woodlands often have sunbeams, thanks to a combination of high moisture content in the air and dappled light from the openings in the canopy.

CLOCKWISE FROM TOP LEFT
• Here the atmospheric perspective is strong and the distant islands are coloured blue, thanks to the haze scattering light in the same way that the blue sky does.

• The deep shade below the trees adds extra contrast against which the sunbeams stand out.

• A very dense fog in overcast conditions – here the light is perfectly diffused. Compare this to the very directional light in the previous example.

• Water can also create dense layers of mist that catch the light of the sun.

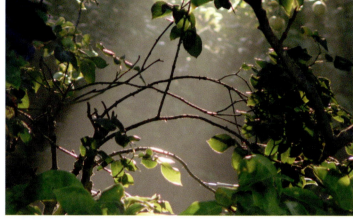

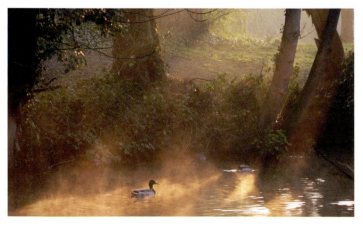

Planes of light

A typical landscape will generally conform to a certain value range based on the brightness of the sky: the sky will be the brightest element, the ground will be the next brightest, and then trees and foliage will be several values darker. This is because of the distribution of the light: with the sky as its source, the light will be very bright, the ground will be darker than the sky but still bright because it is facing up to the sky, and the trees, by virtue of being at a greater angle to the light in comparison to the ground plane, will be darker still. This rule of thumb occurs in most lighting conditions, whether sunny or overcast. Saturation levels will also often follow this same scheme, with the amount of saturation dependent on the luminosity of each plane and element.

TOP RIGHT Here you can see the three distinct lighting planes generally found in landscapes: 1) sky, 2) ground, and 3) trees.

RIGHT Another example of the distribution of light: if you squint it is possible to see the values more clearly.

BELOW Here the 'rule' doesn't apply. The highly reflective snow has made the ground lighter than the heavily overcast sky.

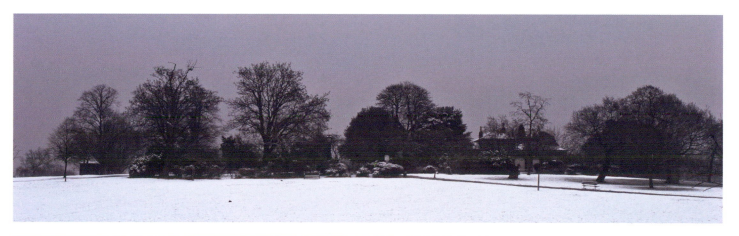

Natural environments

In natural settings foliage can also be an important consideration. One of its main attributes is that it is often translucent and can be very luminous when back lit. This can be a subtle thing to pick up on – a field of grass, for instance, will have a bright, saturated glow when the sun is behind it, but although this is a routine occurrence it is rarely noticed.

In natural environments specularity tends to be visible only close up. Leaves are often waxy and this can give them very strong specular highlights, but once you step back far enough those highlights will be lost because the surfaces are broken up. This means that a wide landscape vista will not contain any specular highlights unless there is foliage in the foreground – the exception to this is where there is water, which can provide large specular surfaces.

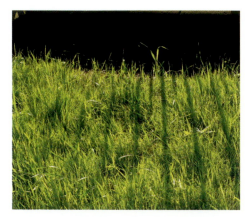

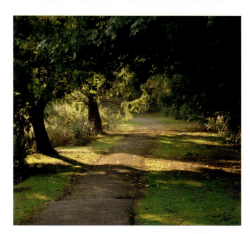

Man-made environments

Large or very prominent specular highlights are pretty much a feature of man-made materials, except of course for the presence of water, as already mentioned. A very wet natural scene, during or just after rain, may well have large specular reflections on some surfaces, but otherwise they are fairly rare. Man-made materials though, especially metals and glass, which are abundant, often have very reflective surfaces.

Urban environments differ from natural ones in several distinct ways. First, they are often far more organized and ordered, with a profusion of straight lines, which in nature are very rare. Second, they also have many more flat planes (on roads, pavements, the sides of buildings, and so on). Third, they have more reflective surfaces, and more regularity, symmetry and smoothness in their surfaces and structures. Whereas nature is dominated by soil and plant matter, urban areas are built of stone, metal and glass.

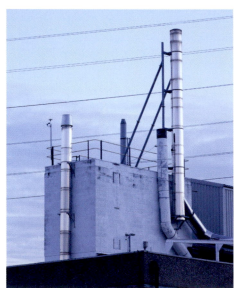

These materials are highly reflective and unmistakably man-made. Note the strong influence of the environment colour on the surfaces.

In this scene lit by bright sunlight there are some small specular highlights dotted about the foliage, but the really large reflective areas are found only on the man-made objects.

The typical surface qualities of modern architecture: smooth, hard and very reflective. Straight lines and smooth curves are the dominant forms. These elements are as far from the organic as it gets.

An example of the juxtaposition of old and new. Note how the materials have very different reflective properties. Also note how dark the windows are: in daylight it's much darker indoors than out, so windows are usually black, except where they are reflecting their environment.

These distant skyscrapers have large uninterrupted areas of specular highlight, a visual clue that tells us that they are made of metal and glass.

Here there are fewer reflective surfaces, but straight lines and symmetrical curves still dominate.

Interior spaces

Interiors are another aspect of man-made environments, and come in many guises. Interiors can utilize natural light, artificial light, or a mixture of both. Natural light is considered to be more pleasant than artificial lighting, so most of the buildings we live or work in try to maximize the use of this better quality of light with windows and skylights.

Working or living in a windowless room feels oppressive and unpleasant. This means that our interiors will often be subject to changing natural light, in a similar way to the outdoors: a window can have sun streaming through it at certain times of day, or it can cast a cool blue light from the sky or the white light of overcast weather into a room. Windows make our interiors changeable and alive, their light following the rhythm of day and night and connecting us to the outside world.

In some interiors, where natural light is not available, artificial light is the only solution, and this means that these places have very constant lighting that doesn't vary according to the time of day or the seasons. Lighting in these environments tends to be primarily functional rather than aesthetic.

ABOVE The different levels of this building receive different amounts and types of light: natural light from the skylights in the ceiling and illumination from artificial lights. Note the difference in colour temperature between the natural and artificial lighting.

RIGHT This gallery is flooded with uniform, natural cool daylight coming from the rows of large windows on either side of the room.

A typical modern interior, maximizing the availability of natural light to create a pleasant living space.

This shopping arcade features mixed lighting. There is a very large glass front on the left-hand side that floods the building with natural light, but as you move deeper into the space, falloff causes this light to diminish, so artificial light is needed to complement it. The natural light, however, is an essential part of this space.

Beneath the arches of this building the light levels are much lower. With no windows in this part of the building it is very dark, despite the skylights above.

In this subway station there is no natural light, because the tunnels were built deep below the surface. Here artificial light is essential, and its design is very functional: the uplighters reflect back off the white ceiling, which is essentially being used as a cheap and convenient diffuser.

Night-time

In populated areas at night there is likely to be a lot of artificial lighting, and the larger the population, the more lighting is likely to be necessary. Artificial light outdoors at night is quite constant, rarely changing because of the absence of the influence of natural light. The only significant change in conditions might be brought about by rain, which will create far more reflections than would exist in dry weather. In cities there is likely to be an enormous variety of different lighting schemes, ranging from street lights to floodlights, vehicle lights, shop lighting and residential lighting. As a result of this there will be a range of qualities, strengths and colours in the lighting schemes. In urban settings you will find a mix between the functional (street lights, illuminated signs and the like) and the decorative (lighting features, shops, and so on). Artificial lighting, especially advertising or neon signs (even floodlighting), can be very highly saturated because of its luminosity and the use of very pure colours.

This building has been floodlit as an architectural feature.

The entrance to this hotel has been decorated with fairy lights as an attractive way of drawing attention to it.

Many commercial buildings will be floodlit to make them stand out. In this case it is a decorative way of drawing attention to a restaurant.

The colour temperature of the neon lights in this office is clearly visible from the street.

The interiors of bars and restaurants will often be clearly visible from the outside, adding another dimension to the lighting encountered in a busy city.

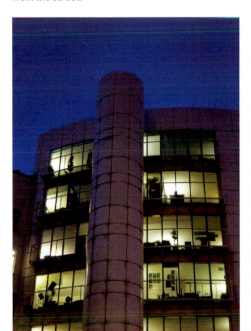

Shops, bars and restaurants will often have lighting with the purpose of attracting passing trade. It can be subtle or, as in this example, gaudy.

Vehicles, traffic lights and road signs also contribute significantly to the lighting in a modern city.

EXERCISE 12
Alien landscape

This exercise looks at the process of lighting an environment that is set in an alien world, such as you might see in a science-fiction film or a computer game.

The primary aim is always to convey the right kind of emotion and atmosphere. Creating environments is not just about realistically reproducing what exists in nature, but, as you will see in the final three chapters of this book, it is in fact mostly about creating a mood in order to communicate something to your audience.

The landscape shown here was intended to convey a sense of mystery and apprehension: there are two explorers wandering into an alien jungle environment, and they are stepping out of the light and into a darker and possibly dangerous place.

12.1 There are several things to note here, the first of which being that in any outdoor environment, particularly one that is being used to establish a new location, it is important to convey a sense of depth. The standard technique for doing this is by using layering: you create a foreground, middle ground and background and use overlapping shapes to separate them from one another.

The second method for creating depth is to use perspective, both standard and aerial, in order to make the background recede. As things go further back they get smaller and lighter, have less contrast and are less saturated. In this case, having the figures also helps to give a sense of scale to the whole environment.

12.2 When there are two relatively small figures in a much wider environment, it is important to compose your image carefully so that they are the main focal point. You can see several ways in which this has been engineered in this image: first, the only bright light in the picture is directly behind them, which immediately draws the eye to them. Second, almost everything else in the image is pointing back at the figures, from the shadows they cast on the ground to the plants hanging down above them, the flower pointing towards them and even the direction of the blades of grass.

12.3 Once the depth, scale and composition are established you are free to create the required atmosphere. In this case, green and blue hues have been used to signify that this is a very alien place. The forest has been left with as little detail as possible, so that it appears unknown and mysterious, with a slightly foreboding mood about it. As most of the image is dark this helps to convey the sense of isolation that the two figures must feel, lost and alone in this place.

12.4 By suggesting a lot of the detail in the darker parts of the picture it is possible to leave quite a lot to the imagination – the viewer can then fill in with whatever they think is appropriate. As an artist you can let lighting and atmosphere do most of the work, and leave a lot of the details out – this is a more suggestive way of working but one that really helps to stimulate the imagination of your viewers.

PART 3
CREATIVE LIGHTING

Lighting is not solely a technical craft, it plays a fundamental role in storytelling and as such it is a profoundly creative discipline. You can use light to guide a composition, to evoke a mood in your audience, or to give your imagery a sense of time and place. Lighting is also a powerful way to arouse emotion.

13: COMPOSITION AND STAGING

When it comes to using light creatively there are few rules, and indeed it is important to realize that rules can be a hindrance. Whereas the earlier part of this book dealt with the physical attributes of light, when it comes to art there is only one rule, and it is a very important one: art is not physics.

With this in mind, the first thing that should be taken into consideration is that you should not become too literal and inflexible with the knowledge you have gained about light in the physical world.

Here is an illustration using one of the simplest methods of staging: a spotlight shines on a character to highlight him in a busy environment.

Creating focus

The purpose of imagery is to tell a story, be it an illustration, animation or film. Of course you need a solid understanding of light to tell your story realistically, but at the same time there are many occasions where the lighting has to serve the story rather than dictate it. The simplest example of this can be found in the theatre, when a spotlight is pointed towards the area of interest. This extremely simple device does a very important job: it focuses the viewer's attention where the director wants that attention to be focused. This is usually a character who is central to that scene; everything else is shrouded in darkness because it is not important to the story at this stage.

In reality we obviously don't live in a world where spotlights shine down on people who might have something important to say, yet when you're watching a play at the theatre you would never question this device – you simply accept it unconsciously and follow the story. No matter how crude and obvious the trick might seem, it does not cause any particular problems with the suspension of disbelief experienced by the average theatre audience.

There are of course more elaborate ways of achieving this aim of focusing the viewer's attention where you want it to be, but they are also doing exactly the same thing as our theatre spotlight. On film sets there are many lights, each with a job to do, but staging the scene effectively and establishing a mood is what the lights are for, not for mimicking reality. So even the most elaborate set with hundreds of lights is set up to focus the viewer's attention on what is important to the story, and in many cases there is nothing at all that could be described as realistic about set lighting. For instance, many comedies are lit with very even and bright lighting, to avoid any shadows that might provide a more sombre feel – this is not a reflection of reality but a deliberate device to create a specific mood.

In films you can often find the spotlight trick used more subtly than the example described above. It is quite common to pick out an important character with a spotlight, add a highlight in an actor's eyes with a special light, or use multiple fill lights to lighten or darken areas according to their importance, and of course to use lights to create aesthetic appeal.

Some cinematographers like to have what they call 'motivation' for their lights, meaning that the light should have a logical source that the viewer can understand, but for others this is less important and they will use lights freely for creative reasons without too much concern for whether the light has an obvious source. The truth is, audiences rarely care whether light sources make sense, as long as there isn't a really obvious and illogical clash.

LEFT A spotlight picks out Indiana Jones inside a dark temple. *Raiders of the Lost Ark* (1981)

BELOW This character's face is carefully lit to separate her from the background. *Ready Player One* (2018)

Leading the eye

In the following variations of the same illustration you can see how lighting that appears to emanate from a logical light source such as a window or a candle can be crafted to draw the viewer's eye to the most important areas of the image – the character and the model he is painting. In the first two images the light is natural light coming from the window, but the light has been very careful staged to illuminate the face and direct the viewer's eye to it. The image with more contrast uses direct sunlight streaming through the window and onto the face to draw attention to it, and uses the strong shadows to isolate the face from the background. The second version does something similar but with more diffused light for a subtler effect. Finally, the candlelit version places the candle just behind the charac-ter's hand to create strong back-lit contrast around his hands and face to draw the eye to those all-important parts of the image. You can see that even with motivated lighting that only uses naturalistic light sources you can still create very careful and effective staging.

FROM TOP TO BOTTOM
• Sunlight shines directly onto the character's face to pick him out against the dark, shadowed background. The long shadows on the side of the face help to increase the contrast and draw the eye to this focal point of the illustration.

• This version uses diffuse skylight to achieve the same effect but with more subtlety. The contrast is lower but the light coming in from the window is still picking out the character's face and separating it from the darker background.

• This time the contrast is created with back lighting from a single candle, carefully placed to draw the eye to the most important area of the image.

In this illustration the lighting is more complex and less naturalistic because the lighting from the fire and the floor lamp is supplemented with an invisible spotlight that is used to pick out the character's face. Even though the lighting is artificially staged with this extra light, it still has a natural and believable feel.

In the next image there are three bright areas: the character's face, the fire, and the floor lamp. The very bright highlight coming from the glasses on the character's face helps to pull the viewer's eye to this area rather than the other bright areas in the scene. The lighting in this image is more artificially staged than in the previous example: whereas the three images of the model maker use only motivated lighting (either the sun and sky or the candle), this image makes use of additional spotlights to pick out the face – however, no viewer looking at the image is ever likely to notice this.

Using contrast

The classic method for using contrast to draw the eye to a focal point generally relies on using the lightest light and the darkest dark at the focal point, reserving more muted contrast elsewhere. This technique has been used for centuries across all media, from painting to theatre and film. The effect can be used very dramatically or very subtly, depending on the mood you wish to achieve.

When deciding on the composition and lighting of any image, the best way to work out the various problems is to create a series of thumbnail sketches, as shown right. By working in this format, quickly and on a very small scale, you will be able to try out various ideas without losing too much time on variants that don't work out. It can also save a lot of headaches that you might run into later on if you launch into a detailed image without having thought out potential issues first.

Take a look at the images from art and film shown on these pages to see how contrast has been successfully used as a compositional device.

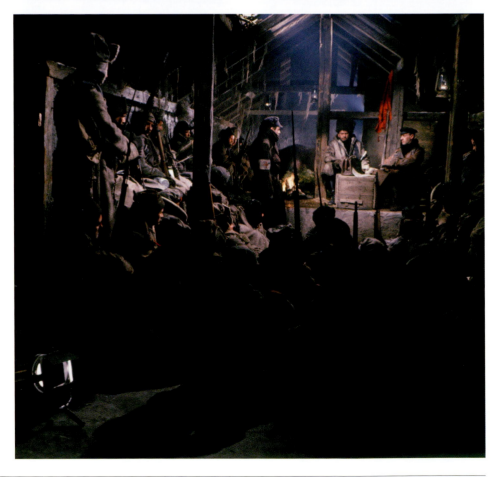

TOP These thumbnails allow you to see the effects of different contrasts. The figure in the top right image is most noticeable as this is the darkest and lightest point.

RIGHT This crowded scene is carefully staged to lead the eye to the characters in the far background by shining the brightest light on them, leaving the numerous foreground characters in obscure darkness. *Doctor Zhivago* (1965)

TOP LEFT Despite the crowdedness of this scene, the focal point of the little girl is clearly defined by the light. Light is used to lead the eye through the painting via the secondary characters. Diego Velázquez, *Las Meninas* (1656)

ABOVE LEFT Although there is a bright area in the top left corner of this image, the eye is drawn to the figure's face. The use of the window as a framing device creates a powerful and startling composition. *Nosferatu* (1922)

TOP RIGHT Light falls on the globe and on the character's face, allowing the rest of the painting to fall into darkness. Johannes Vermeer, *The Astronomer* (c.1668)

ABOVE RIGHT The faces of the characters are picked out by the lighting in this crowded scene, with the main character having the clearest definition. *Darkest Hour* (2017)

Back lighting

Another common and effective way of drawing the eye strongly towards a subject is to use back lighting. Because it is the highest contrast kind of lighting available it is very effective for isolating a subject, often in silhouette, against a bright background.

The spotlight device is often used in conjunction with back lighting, as this creates a powerful staging device that draws the eye immediately to what is often a very small section of an image. This can even allow you to leave the majority of the image in darkness, and use the light to pick out your centre of interest – thus creating a very atmospheric image.

Though this scene is still dark, we are drawn immediately to the characters, isolated as silhouettes by the back light. *A Clockwork Orange* (1971)

This scene from *Skyfall* (2012) combines two lighting techniques: the character is back lit so that he mostly falls into silhouette, and then his eyes are picked out with a spotlight, creating a tense and atmospheric shot.

PART 3 · CREATIVE LIGHTING

Distribution of values

In the top three examples, the three shapes are strongly defined by the way they are placed in the frame. The examples on the right overlap too close to their edges, creating an unbalanced composition.

One thing you should pay close attention to is how contrasting shapes overlap: make sure that their edges are not too close together as this will make them read less clearly; a strong overlap is a much better way to get shapes to read – see the examples above.

Using a pleasing distribution of values is more likely to result in a successful composition, and one way to achieve this is by looking at the values as if they were an abstract design: an attractive abstract design will result in an attractive composition. In animation or special effects, film shots are often planned so that the visual development artists can create strong underlying designs upon which the lighting is based.

ABOVE RIGHT In this shot the values are carefully distributed so that each block of tone occupies its own distinct space, resulting in a very clear composition where each character is clearly readable against the dark background. *Double Indemnity* (1944)

RIGHT In this very carefully staged shot from *The Third Man* (1949) the character is positioned so that the building intersects the silhouette down the middle.

EXERCISE 13
Stylized lighting

There are many different creative approaches to lighting, from very naturalistic lighting that appears to come from realistic light sources or from natural light (sometimes referred to as available light), to very stylized lighting that bears no resemblance to reality. In both cases the lighting has to focus attention on the important parts of the image and to tell the story. With a more naturalistic approach this has to be staged carefully, by placing characters next to a window or some similar device. With a more stylized approach you have more freedom; since you are not aiming to create realism you can place your lights as you wish, but the lighting must still focus on the main subject, so that even the wildest and most creative lighting schemes are subservient to the story.

Here are three examples of stylized lighting that show how even wildly creative lighting schemes can still lead the viewer's eye to the main subject of a scene.

13.1 This very theatrical example uses several lights coming from different directions to separate the characters from the background. There is no sense of naturalistic lighting here; bright spotlights are shining from different directions to pick out the characters. Because the characters are translucent, back lighting is used to separate them out from their surroundings, and the unnatural lighting helps to reinforce the otherworldliness of the scene. The lights on the characters are a cool blue, whereas the lighting on the background elements is a warmer purple, thereby reinforcing the separation between the two. As well as the unnatural colour scheme, the multiple shadows around the main subjects help to indicate that this is staged lighting rather than natural light.

13.2 This is a more subtle example of stylized lighting that mimics a sunset, but with much softer contrast to create a more understated otherworldly feel. Again a theatrical spotlight is thrown onto the characters to pick them out with side lighting, and gentle fill light is used to wash out the scene with soft contrast. A real sunset scene would have a much higher level of contrast, but with stylized lighting you are free to take liberties to create the mood and feeling you want. In this case the colour scheme is carefully calibrated to avoid the potentially treacly mood that sunsets can sometimes result in, aiming for something a little more unearthly.

13.3 Another theatrical example that pays no heed to natural or physical lighting: here we have two spotlights coming from different directions, as evidenced by the shadows under the trees, which are pointing to the right while the shadow cast by the character points to the left. The character is very deliberately picked out with a spotlight to single him out from the surrounding environment, and the colour scheme is warm and lyrical. Again the heavily stylized lighting helps to convey the otherworldly feel of the image, while still serving to tell the story.

13.1

13.2

13.3

14: MOOD AND SYMBOLISM

Light and colour are the key ingredients when directing the emotions of your audience, and almost every work of art, from film to illustration, will use these tools to manipulate the emotional response of the audience. Sometimes this manipulation can be dramatic; at other times it will be subtle, and an audience will rarely realize that it is going on but will nonetheless be affected on a subconscious level.

This character is a cross between human and monster, but the colours are entirely suggestive of the monstrous and reptilian. The overall mood is cool, with the greens dominating, but with warm contrasts in the reds and yellows.

Setting the tone

Several factors play a role in conveying mood in different art forms: how bright or dark the overall scheme is, the colour of the light, its direction, its quality, and its relative familiarity. In films certain scenes or characters may be dominated by a specific colour. This is a very common method of suggesting a mood and uses colour as a storytelling device. There are no limitations or set rules on how mood or symbolism can be conveyed – this depends on the creativity and imagination of the artist. The effects can be either strong or subtle, depending on the situation and the vision behind it.

Mood and symbolism can be used in relation to characters, locations or sections of a story. Lighting is a powerful tool for conveying emotional messages within a story, one that is used in all styles of visual storytelling, from the fantastic to the more mundane. In fact, the use of lighting can be used to set the tone of the story: realistic lighting naturally suggests a realistic story, and lighting that is heightened in its effect can therefore suggest either something unreal or a heightened reality – and sometimes the two can be combined within the same story.

TOP In this scene from *Fantastic Beasts and Where to Find Them* (2016) the lighting is realistic and mundane to signify that the scene takes place in the real world.

MIDDLE In the same film, in the sequences inside the magical suitcase, the lighting is heightened and more stylized and colourful, which helps to convey the otherworldliness of this place.

BOTTOM Scenes involving the Magical Congress have lighting that is much darker and cooler, to emphasize the secrecy and shadowy nature of this magical world in relation to the ordinary world.

Lighting characters

Mood and symbolism are generally applied to three key elements: characters, locations and the narrative arc. Each one of these can be lit in such a way as to determine how the audience will perceive them. There is a huge variety of characters, some good, some bad, and many occupying the grey area in between. The way a character is lit can really help to convey their personality and lead the audience into feeling a certain emotion. In an extreme situation, a character representing good might be lit in such a way to appear heroic or even godlike, whereas a character representing evil could be lit to look extremely sinister.

Lighting from below is a device often used to create a monstrous effect, and allowing one half of the face to fall into shadow adds to the drama and suspense of the image.

The overall colour of the lighting is a very important aspect in its symbolic use. Cool blue light can suggest coldness, night and death; warm red light can be used to create a sense of anger or danger. An overall colour cast is a frequent device used in film where the film is artificially graded or a filter is used; comic books and graphic novels also use colour casts.

MIDDLE LEFT In this scene from the television series *Game Of Thrones*, the character of Varys is lit in a dim green light, giving him a sinister and shadowy appearance that symbolizes his deviousness.

BOTTOM LEFT Here, the character of Tyrion is also lit in a low-key high-contrast way, but the warmer colour of the lighting gives him a more sympathetic appearance compared to the unnatural green that was used for Varys.

BELOW The character of Daenerys is lit in a softer and more pleasing way, immediately creating a more idealized and appealing mood that subconsciously tells us she is on the side of good rather than evil.

LEFT The monster is lit from below and to one side to create a sinister effect. *Frankenstein* (1931)

BELOW This surreal imaginary world uses desaturated, stylized colours to symbolize its strangeness and otherworldliness.

BOTTOM This character from *Avatar* (2009) is lit with bright, saturated lights using unusual colours to symbolize the alien nature of both the character and the world she inhabits.

Lighting environments

Lighting is an essential ingredient when creating a mood for a particular time and place. Locations can be lit to create a certain feeling or to symbolize an idea: the quality of lighting, its colour and key, can be used both for subjective purposes and to create a response in the audience. A location that is bright and sunny will have a completely different feel from one that is dark and gloomy. Light is associated with good, and darkness is symbolic of evil.

There are no limits on how light can be used subjectively – audiences will respond positively by suspending their disbelief and going with the action rather than noticing the often unnatural or unrealistic lighting used for artistic purposes. You can take a great many liberties without destroying the illusion of reality, since the story always takes precedence over any concerns about realism or accuracy.

TOP Bright colours and even lighting dominate the palette in the US series *Curb Your Enthusiasm*.

LEFT In this scene from *The Third Man* (1949), the lighting in the underground tunnel is very harsh, with hard shadows and high contrast adding to the sense of intrigue.

<u>TOP</u> In this scene from *The Hobbit, An Unexpected Journey* (2012) the lighting is used to create an idyllic and beautiful location.

<u>ABOVE</u> In this shot, also from *The Hobbit*, the use of cooler colours and low-key lighting creates a darker and more sinister mood to depict Gollum.

Using lighting to enhance the story

The final common aspect of lighting for mood comes in relation to the narrative arc: one section of a story will be lit differently from another in order to suggest an emotional shift in the narrative. This can be used to illustrate the feelings of the protagonists, to direct the emotions of the audience, or simply to illustrate the different sections of a story.

By using lighting to guide the emotions of an audience, the story is enhanced and the emotions are felt more keenly. Music is often recognized as playing a crucial part in controlling how an audience responds to cinema, but lighting is a powerful and important tool that works in a similar way – and it can also be applied in other contexts, such as illustrations and comic books.

Lighting does not have to be literal. The colour and quality are often carefully decided based upon the emotional response they are likely to provoke – everything is subservient to the story or to the message. That realism is not always the main concern, however, rarely causes any kind of problem because audiences tend not to worry about realism, wanting simply to be involved with an engaging story or a work of art that has resonance. This means that an artist has tremendous freedom to manipulate lighting for creative ends, to produce any kind of mood, or even to use it as an overt symbol with which to reinforce their message.

TOP In this still from the early part of the film *La La Land* (2016), the lighting is everyday and mundane to signify that the scene is depicting what is so far just an ordinary day.

ABOVE Later in the film, more heavily stylized and unrealistic lighting is used symbolically to transport the viewer into a more fanciful and whimsical world.

TOP In *2001: A Space Odyssey* (1968), light is used to symbolize the state of mind of HAL, the computer. White light suggests both purity and space-age technology.

<u>ABOVE</u> Later in the film, the computer goes haywire, and intense red light is used to signal madness and danger. The setting is identical, but the mood is very different.

EXERCISE 14
Lighting for mood

Several factors play a role in conveying mood: how bright or dark the overall scheme is, the colour of the light, and its direction, quality and relative familiarity. It's worth spending some time experimenting and setting up exactly the right kind of lighting to convey the specific mood you are looking for. Creative lighting is about far more than just making your characters and environments visible – it's also about how you want your audience to react to them.

There are some cases where the mood of an image is its most important aspect, and others where mood has a more subservient role. In neither case can the mood be ignored because it is important even when not the key to the image. To demonstrate just how big a role lighting plays in creating mood, let's look at how the same subject appears under four different lighting schemes.

By comparing these four examples, you will get a small taste of just how much difference lighting can make to the mood conveyed by a simple character. The further you stray from the ordinary, the greater the emotional impact is likely to be.

14.1 Under very flat, diffuse lighting you can see the character clearly. However, there is little in the way of emotional impact here – this kind of lighting is often used when the subject itself is paramount (such as a product shot or a portrait). You can see the subject clearly without being distracted by any other factors.

14.2 If the character is then lit to simulate a typical sunny outdoor situation, more life is immediately added to the image and a sense of context is created. In terms of mood there is also an improvement, but since this is a fairly ordinary and everyday situation this is not dramatic.

14.3 If the character is then placed in very low-key cool lighting, things change considerably. There is now a distinct air of menace and mystery, and the character conveys a completely different feeling. Once the lighting departs from the ordinary and the everyday it conveys far greater meaning in terms of mood. Atmosphere, rather than functionality, becomes its main purpose.

14.4 In the final example, the warm and high-contrast lighting coming from below immediately creates something mysterious and spooky, yet appealing. This is not the kind of lighting usually seen in everyday life, and this very unfamiliarity helps to create the atmosphere. The unusual is much more likely to create an emotional impact.

15: TIME AND PLACE

Light is often used as a defining element in storytelling, a way of partitioning locations, periods or even segments of a single story, much like the chapters of a book. There are several reasons for this: to differentiate different places or times within a narrative, to create associations of mood with a particular location or time, to recreate some authenticity of the past or suggest some imagined future, or simply to create variety.

A weird and otherworldly feel is created with the lighting of this strange character in an alien environment.

Period lighting

In contrast to the more symbolic uses of lighting, this is a more pragmatic and practical aspect of light: to establish the period in which the scene takes place, the kind of lighting and materials available, and what this means in practical terms.

Period settings can be more convincing if the lighting is a realistic reflection of the technology available at the time in which the story is set. A scene from a period prior to the invention of electrical lighting could require lighting that resembles lamplight, candlelight or firelight. Lighting such a scene with powerful white light would be less convincing – the anachronistic lighting might distract from the story.

Of course there's more to this than just the literal representation of period lighting – lighting and materials are often used to convey specific feelings about a location and to drive the story. This is often so subtle that audiences will not be consciously aware that they are being manipulated in this way.

Lighting can be used in a variety of ways to suggest specific ideas about a period or a location: artificial lighting is always a product of technology, so this is one of the primary aspects used to represent period or cultural elements of a lighting set-up. The materials used, and how they react to light, are also extremely important considerations. Again, this will reflect the technology of the period as well as specific circumstances relating to the story elements.

TOP This shot from *12 Years a Slave* (2013) was achieved using warm, high-contrast lighting from fire and candlelight to represent the lighting allowed by the technology of the period.

ABOVE The lighting in this scene from *Avatar* (2009) is futuristic and technological, reflecting the future in which the film is set.

Establishing location

The narrative arc is also an important consideration: lighting can be used to divide the story into segments. In Chapter 14 we saw how this can be done in terms of mood, but it can also be done more pragmatically: different locations, cultures or periods will have different kinds of lighting and materials and this can be exploited cleverly to drive or divide the narrative.

This device is used to great effect in the *Star Wars* films. There is a separate universe, which is very diverse and has a large number of different locations, as well as three (or likely more, in future) distinct epochs. These separate the original trilogy from the prequels and sequels, which were filmed later. All sets of films have a separate look and feel, which helps to explain how things have changed in the time that separates them within the story.

The Empire is defined as a very stark, high-tech world, and Darth Vader epitomizes this look: he wears a glossy black helmet and is covered in electronic-looking lights. The materials used in his costume are high-tech and extremely reflective. The Empire locations are very similar in design, and their look and feel is also echoed by the lighting and materials used to represent the First Order in the later films. The surfaces used are usually reflective, very flat and with a profusion of small lights everywhere.

Any environment associated with the Rebels (or, later, the Resistance) is based on organic forms and natural materials, from Tatooine to Dagobah (where Yoda resides) to Endor (the planet of the Ewoks). These separate locations are given their own distinct look based upon common design elements. Tatooine is a desert, Dagobah is a swamp and Endor is a dense forest. This means the locations look different in terms of materials and lighting, but the same kinds of organic forms and non-reflective natural materials are used to create their own separate visual identity while keeping to a common theme: natural, organic and low-tech.

Ridley Scott's *Alien* (1979) also uses this technique to visually separate the two spaceships in the film, one populated by humans and the other by an unknown and now dead alien species, which has been colonized by the hostile aliens of the title. The human spaceship is brightly lit with no hard shadows, and is designed around clean white shapes and symmetrical patterns. The alien spaceship is lit far more atmospherically, with a lot of dark shadow, strong blue and green colour schemes, and sinister organic shapes reminiscent of bones and organs. The strong visual contrast between these two locations helps to emphasize the alien aspect of the unknown ship – it is everything that the human one is not: dark, creepy, organic and grotesque.

The highly reflective world of the First Order in *The Force Awakens* (2015), starkly lit with futuristic-looking lights, and with very unnatural-looking red and green colour casts.

RIGHT The world of the First Order is an artificially created, hard and glossy environment that is devoid of natural daylight.

MIDDLE In comparison, the worlds of the Resistance are organic and bathed in natural light. The forms are soft and rounded, there are no hard reflections, and it feels much more welcoming and natural than the cold environment of the First Order.

BELOW LEFT & RIGHT The human and alien spaceships in the film *Alien* (1979) are easily distinguished by their very different lighting effects.

Breaking up the narrative

A good example of the use of different lighting and colour schemes to break up the narrative and represent different sections of a story is the comic book *Thorgal – Au-delà des ombres* (1983) by Jean Van Hamme and Grzegorz Rosinski. The story takes place in several locations, ranging from a village to a supernatural afterworld, and the authors segment the story visually by giving each location a distinctive appearance. Each place has its own lighting and colour palette, with its own very strong visual identity.

Changing the visual landscape in this way really helps to involve the reader in the story, by throwing up surprises that stimulate the imagination; it also helps to propel the narrative forward. It produces a very similar feeling to what you might get playing a computer game: when you reach a new level, with visuals that are completely different from those that you have seen before, it excites your imagination and helps to immerse you more deeply in the world the game is set in. The same device can be used in any narrative, and is a powerful way to hold the interest of an audience by feeding their imaginations with something new.

In many computer games there will be a strong visual differentiation between different levels as players progress through the game, with each new level having often radically different lighting and colour schemes from what has come before. The artists will go to enormous lengths to make each location different from the others in terms of lighting and colour. This helps to break up the story into different sections and is a real incentive to progress further and see what comes next.

Each of the different levels in the computer game Overwatch features an instantly identifiable lighting and colour scheme.

Tonal values ring the changes as this comic book story moves through different realms.

Time

The concept of light can also be used to describe the passage of time in a more literal and obvious way. Day and night are a simple example, or the subtle changes in light during the course of days and seasons. French artist Claude Monet made the concept a major part of his work when he began painting his various series in the late nineteenth century, where he would pick a subject and paint it many times, the successive images describing the changing light upon them at different times of day.

This resulted in an enormous number of different paintings that are surprisingly varied and explore the complex subtlety of the changes in light and atmosphere that occur over days and seasons. The narrative here is simply the light itself and how it changes constantly over the course of time. The fact that the subjects in a series remain the same but the paintings look so different from each other, says a great deal about the power of lighting and atmosphere when it comes to creating mood, establishing the time of day and dictating the overall colour scheme. Think how effective this is when it is simply describing natural light – once imagination is added to the mix; the possibilities are endless.

The actual subject matter in these paintings is secondary. Light itself is their real subject, but one that shows enormous range and variety. It's a worthwhile exercise to pursue with a camera, a sketchbook or even in 3-D renders of a single scene: you will learn how many different variations a single subject can provide under a range of different lighting and atmospheric conditions.

By learning to see light in this way you can open up a whole new language to use in your own work – one that is not just a technical trick but that can be used to convey any kind of message you choose – it's entirely up to you and your imagination.

While the subject remains the same, the paintings in this series by Monet couldn't be more different from each other, so altered are they by the light at different times of the day.

EXERCISE 15
Time of day

Light is the means by which changes in the time of day are perceived. In both subtle and dramatic ways, the changing light throughout the course of the day marks the progression from morning to night.

If demonstrating the passing of time is an important aspect of your narrative, lighting is the tool with which you can achieve this. The passage of time might be important for pacing purposes or to differentiate between different segments of a story. Its purpose might also be symbolic. With the appropriate variation in your lighting you can illustrate the transitions through the day, and even the changing seasons.

Below are a series of images of a fairly simple computer-rendered interior scene that show how much impact the different lighting schemes for different times of day have on the scene.

15.1

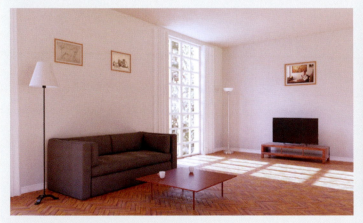

15.2

15.1 To begin with the scene has been set up to have bright sunlight coming through the windows – the kind of light you would have on a bright, sunny day. The light is relatively neutral in colour and floods the room. The windows here are providing all of the lighting – the light is being bounced by the walls, floor and ceiling to illuminate the entire room. This image has been tuned to look bright and low in contrast, almost verging on the high-key, which helps to convey the time and feel required – a bright and mostly diffuse lighting situation. The thin sliver of bright direct light becomes diffused by bouncing around the room.

15.2 If the bounced light in the 3-D renderer is then turned off you can see the difference not having bounced light makes.

15.3

15.4

15.3 As evening comes, the lighting can be changed dramatically. The low sun is still shining directly through the windows, but at a different angle. At this time of day the sun is weaker because the light is travelling through a much thicker layer of atmosphere, so the overall contrast from the direct sunlight is much lower. The red sunlight creates a strong colour cast and the whole scene is affected by it. This image has a very different look and feel from image 15.1 and there is no doubt that the time of day has changed.

15.4 Finally, there is night-time and, again, a big change. The light from outside is too dim to provide enough illumination so artificial light now plays a much more important role. In this case the lighting is still designed to be dim, but bright enough to see clearly by. By using a less atmospheric lighting scheme (a bright ceiling light, for example) you could create further variations for this time of day. Again, these could be used to punctuate a story where different scenes require different lighting. By marking the change in time in this way you can use light to depict the unfolding of the story you are telling.

GLOSSARY, INDEX
& PICTURE CREDITS

GLOSSARY

3-D
Three-dimensional; a 3-D image appears to have height, width and depth, thus conveying a convincingly lifelike quality.

additive colour model
Mixes together the primary colours of the visible light spectrum to produce different colours. When all three primary colours are combined in equal quantities the appearance of white is produced. Television screens and computer monitors are examples of systems using additive colour. *See also* colour spectrum, primary colours of light.

alpenglow
Originally a reference to the reddish-orange light that can be seen at dawn and dusk on snow-covered mountain peaks, the term has come to be used to describe the pink light cast onto any reflective surface from the eastern sky.

ambient light
In CG terms ambient light is a directionless and even environmental light source, usually with a very low intensity. In the real world it is the existing environmental light created by the mixture and bouncing of all existing light sources.

ambient occlusion pass
An optical illusion that adds depth to an image by shading around the areas where surfaces meet in order to simulate the effect produced by a large, diffuse light source.

anisotropic reflection
A reflection that is distorted by irregularities on the reflective surface. *See also* distortion.

back lighting
A method of artistic lighting where the light source is behind the subject, helping to separate the subject and its background, thus giving a more three-dimensional appearance to the image. *See also* rim lighting.

base shadow
A shadow placed at the base of an object that sits on a surface, making the object look more naturally placed.

bevelled edge
An angled or rounded edge, commonly found on most man-made objects; bevelled edges catch light from a variety of different angles, providing multiple reflections.

blocking in
A technique used by artists whereby they sketch in the larger shapes in an image before attending to the detailing.

bounce
See bounced light.

bounced light
Light that reflects off surfaces, adding to the overall illumination of an environment and softening the overall effect of the lighting.

cast shadow
Created by an object blocking the source of light, cast shadows are what we generally think of as shadows and are usually hard-edged. *See also* form shadow.

caustics
Occurs where light is reflected or refracted by a curved or distorted surface, creating patterns of light such as can sometimes be seen on the bottom of swimming pools.

CG
Abbreviation for computer graphics. The use of computer software to create and manipulate images.

cloud cover
A sky condition that has the effect of diffusing sunlight so that the sun's rays emerge from the cloud in different directions.

colour cast
An imbalance of the primary colours in a light source produces a cast of the most prevalent colour over an image, but this is usually filtered out by the brain (which tends to perceive light as being neutral) so that it becomes apparent only in photographs. *See also* primary colours of light, white balance.

colour intensity
The intensity and purity of a colour. The more white light, the lower the intensity of the colour, which will have a pale, washed-out appearance. Also known as colour saturation.

colour perception
Human colour perception is based on the primary colours red, green and blue and is highly subjective.

colour saturation.
See colour intensity.

colour spectrum
The grouping together of light waves. The wavelengths we can detect as colours (ranging from red to violet) form the visible light spectrum. Those waves outside the colour spectrum in the shorter range are ultraviolet, X- and gamma rays, while those in the longer range are infrared rays, microwaves and radio waves. *See also* white light.

colour temperature
Measures the heat of a colour in visual terms. The closer a colour is to red or orange, the warmer it is considered to be, while it is perceived as growing colder as it travels along the visible spectrum towards blue. However, scientifically speaking, red is at the cooler end of the scale, and blue at the hotter end. The hotter a flame burns, the more it tends towards blue.

colour value
The lightness or darkness of a colour.

colour wheel
The arrangement of the colours of the visible light spectrum in a continuous band.

contrast
The perceived difference in tones that are adjacent to each other. Low-key lighting creates high contrast, while high-key lighting produces low contrast. Hard edges and glossy surfaces create higher contrast than soft edges and matte surfaces. *See also* fake contrast, high-key lighting, low-key lighting.

curvature
The soft transition from light to shadow that occurs when an object is curved. A hard edge produces no curvature.

dappled light
The areas of light and shade produced when light is filtered through a broken mass, for example when sunlight shines through trees.

dielectric
A substance that doesn't conduct electricty.

diffuse lighting
Light that is softened by passing through a translucent diffuser or by reflecting off a diffuse surface.

diffuse reflection
The scattering of light by the reflective surface as a result of how light and matter interact with each other. Most natural materials produce this type of reflection, which is what enables us to perceive the texture and colour of objects. *See also* scattering.

direct reflection
The clear reflection that is produced by light reflecting on shiny surfaces, such as water or polished metal. Also known as specular reflection.

distortion
The effect on a reflection of any irregularity in a reflective surface. The reflection will be distorted along the length of the surface irregularity. Curvature can also distort reflection. *See also* anisotropic reflection.

fake contrast
Increases the contrast between edges to create a higher contrast than actually exists. This effect is achieved by the brain working to produce an acceptable level of contrast. Photo-editing software can mimic the process.

falloff
When a light source decays, becoming less bright as the light moves away from its source.

fill light
A secondary light source used to illuminate shadows.

flat front lighting
A light source shining from directly in front of the object, creating a flat effect that reveals very little texture.

fluorescent lighting
A form of non-incandescent lighting with a greenish-bluish cast, generally used for lighting public places.

form shadow
A subtle, soft-edged shadow on the side of an object that is facing away from the light source, the side that the light can't reach. Specular and highly transparent surfaces have no form shadows.

Fresnel effect
More or less reflection will be seen on a surface depending on the angle from which it is viewed.

golden hour
The hour before sunset, when evening light produces warm colours and soft contrast. Also known as the magic hour.

gradation
The gradual change in the density of a colour, caused by various factors, including transitions, falloff and scattering.

haze
Caused by articles of dust or other matter in the atmosphere scattering the light. Depending on how thick it is, haze can alter perception to a greater or lesser extent.

high-key lighting
A low-contrast style of photographic lighting, achieved by using back light and fill light to reduce the contrast between light and dark areas. *See also* low-key lighting.

hot spot
The reflection of a light source on a diffuse surface. Unlike a specular highlight there is gradation from the hot spot into a darker tone. *See also* specular highlight.

hue
Value of a colour on the colour wheel.

hue variation
The variation of the local colour of an object for any reason. *See also* local colour.

incandescence
The emission of light by a heated source.

incandescent light
Light produced by incandescence; usually used for indoor lighting. *See also* tungsten lighting.

light-emitting device
Any electrical appliance that emits light, such as a computer monitor or television screen.

light pollution
The intrusion of artificial light into areas not intended to be lit at night.

local colour
The colour, or hue, of an object.

lost edge
An effect produced by the brain, and mimicked in painting and photography, whereby the edges of objects are 'lost' so that there is less contrast, creating a softer transition.

low-key lighting
A style of photographic lighting that relies on high contrast between light and shade to create dramatic effects. *See also* high-key lighting.

luminosity variation
Uneven light causing variation in the appearance of a surface.

neutral lighting
Lighting that provides shadows with the same colour saturation as the lit areas. *See also* colour intensity.

north light
The most consistent natural light source, which, being diffuse, casts no shadows. Traditionally, a north-facing studio provided the optimum light conditions for artists.

one-point perspective
Used to render a subject head-on, with the perspective receding towards a single vanishing point. *See also* vanishing point.

overcast light
The type of light produced when there is cloud cover. Cloud is cast over the light source, the sun.

penumbra
The lighter part of a shadow as it approaches the edge. *See also* umbra.

perspective
A technique that is used in drawing and painting to provide a sense of space and distance. *See also* one-point perspective.

planes of light
The three distinct lighting planes in most landscapes: the sky, the ground and any trees or foliage. The brightest plane is usually the sky, while the darkest is the middle plane, containing the trees. However, this will alter depending on weather conditions and time of day.

primary colours of light
Red, green and blue (RGB) are known as the primary colours of light – mixing them in different combinations produces all the colours of the visible light spectrum.

radiance
The effect produced by light bouncing when it hits a surface that is any colour other than black. Different-coloured surfaces will absorb different wavelengths of light, so the colour of the radiance will depend on the colour of the surface.

raking
Illuminating a surface with the light source at an oblique angle to the surface. The light rakes across it, showing any texture and distortions in the surface.

refraction
The slowing down and bending of a light ray as it passes from one medium to another, for example from water to air. The degree to which it bends depends on the refractive index of the material through which the ray is passing. Light waves of different energies, or colours, will bend at slightly different angles. *See also* refractive index.

refractive index
A measurement of the speed at which light passes through a material. Air has a lower refractive index than water, which, in turn, has a lower index than gemstones. The lower the index of a material, the greater the degree to which the light will slow down as it passes through.

rim lighting
Back lighting that is positioned in such a way that it highlights the edges of the subject. It is particularly effective when the subject has a degree of transparency or translucency.

scattering
The multidirectional reflection of light by the medium through which the light passes, or is reflected by, for example, water or dust. The degree of scattering depends on the nature of the material. *See also* diffuse reflection, haze.

secondary light
Light reflected by a secondary light source. The sun is a primary light source whose light is reflected by the moon, a secondary light source.

skylight
The natural light that comes from the sky at any time of day or night.

softbox
A piece of photographic equipment that diffuses reflected light directed at the subject of a photograph, creating a soft, diffused light.

spectrum
See colour spectrum.

specular highlight
The reflection of a light source on a shiny surface. It appears as a bright spot of light.

specular reflection
See direct reflection.

surface modelling
Defining shapes by means of light falling across them.

surface normal
The angle that is perpendicular to a surface. On a curved surface this angle varies according to the curvature of the object.

terminator
The border between the area of an object that is in light and the area that is in shade.

texture
The surface quality of a material, describing attributes such as coarseness or smoothness.

three-point lighting
A formula for photographic lighting. It uses a key light that shines directly onto the subject, a back light and a fill light. *See also* back lighting and fill light.

tonal variation
Variation in colour that aids our comprehension of an image. *See also* tone.

tone
The darkness or lightness of a colour, also known as the value of a colour. All colours have a variety of tones, with darker hues having a larger tonal range than lighter ones. Colour tone is relative in that it is affected by the surrounding colours.

transition
The point at which an object moves from shadow into light or vice versa. The harder the edge of an object, the harder the transition; a softer edge makes for a softer transition. The transitions help define the shape and composition of an object.

tungsten lighting
A type of incandescent lighting with a yellowish-orange cast, generally used for lighting domestic interiors.

umbra
The central and darkest, hardest-edged area of a shadow. *See also* penumbra.

vanishing point
A point on the horizon used as a point of convergence for conveying perspective. One-point perspective has a single vanishing point, two-point perspective has two vanishing points, and so on.

volume
The space occupied by an object. No matter how complex the shape of an object, its volume is always defined either by planes of light or by rounded forms.

white balance
A facility on digital cameras that enables the user to remove the colour cast from an image when there is a colour imbalance, just as we do with our eyes, so that the colour balance in the photograph is as we expect it to be.

white light
The colours of the spectrum, blended together. *See also* colour spectrum.

INDEX

Picture Credits

The publisher would like to thank the following individuals and institutions for providing images for use in this book. In all cases, every effort has been made to credit the copyright holders, but should there be any omissions or errors, the publisher will be pleased to insert the appropriate acknowledgement in any subsequent edition of this book.

Except for those indicated on this page, all photographs and illustrations in this book have been created by and are the copyright of Richard Yot.

Chapters 1–11
16 Donaldson Collection/Michael Ochs Archives/Getty Images • 19 Shutterstock/ Puhhha • 40 The Ronald Grant Archive/ Warner Bros. • 57br © Christophe Stolz, used with kind permission • 103t ©1995, Edward H. Adelson • 124t Shutterstock/ Anetta • 124b Shutterstock/Irina Bg

Chapter 13
141l The Ronald Grant Archive/Lucasfilm/ Paramount • 141r Shutterstock/REX/ Moviestore/Warner Bros. • 144b The Ronald Grant Archive/MGM • 145tl The Artchives/ Alamy • 145tr ©Photo Josse, Paris 145bl Alamy/Pictorial Press Ltd. 145br Jack English/Working Title/Kobal/ Shutterstock • 146t Danjaq/EON Productions/Kobal/Shutterstock 146b The Ronald Grant Archive/Warner Bros. • 147c The Ronald Grant Archive/ Paramount Pictures • 147b London Films/ Kobal/Shutterstock

Chapter 14
151 Warner Bros./Kobal/Shutterstock
152 HBO/Kobal/Shutterstock
153tl The Ronald Grant Archive/Universal Pictures • 153b Twentieth Century-Fox Film Corporation/Moviestore/Shutterstock
154t HBO/Kobal/Shutterstock
154b The Ronald Grant Archive/British Lion Film Corporation/London Film Productions
155 New Line/Kobal/Shutterstock
156 Dale Robinette/Black Label Media/ Kobal/Shutterstock • 157 MGM/Stanley Kubrick Productions/Kobal/Shutterstock

Chapter 15
161t Moviestore/Shutterstock
161b Twentieth Century-Fox Film Corporation/Kobal/Shutterstock
162, 163t, 163c Lucasfilm/Bad Robot/Walt Disney Studios/Kobal/Shutterstock
163bl, br Twentieth Century-Fox Film Corporation/Kobal/Shutterstock
164t (3 images) ©2018 Blizzard Entertainment, Inc. All Rights Reserved
164b Au-delà des Ombres (5), ©Le Lombard (Dargaud-Lombard), 1983 by Van Hamme & Rosinski • 165l Claude Monet, Rouen Cathedral, Effects of Sunlight, Sunset, 1892 (oil on canvas) Musée Marmottan, Paris/ Bridgeman Images • 165c Claude Monet, Rouen Cathedral, Effects of Sunlight, Sunset, 1892 (oil on canvas) World History Archive/Alamy • 165r Claude Monet, Rouen Cathedral, Full Sunlight. Harmony in Blue and Gold, 1894. (oil on canvas.) Classicpaintings/Alamy

Acknowledgements

I would like to thank the following people for helping me to get this book realized: Brian 'Ballistic' Prince for featuring my original tutorial on CGTalk.com and generating the initial interest that helped me recognize the potential for this idea; Melanie Stacey for her help in getting the proposal in front of the right people; my friend Christophe Stolz for letting me use one of his photographs; my wife Anne-Marie for her infinite patience while I wrote the book; and finally, thanks to all at Laurence King for the work they did on the book.